Looking at

Manet

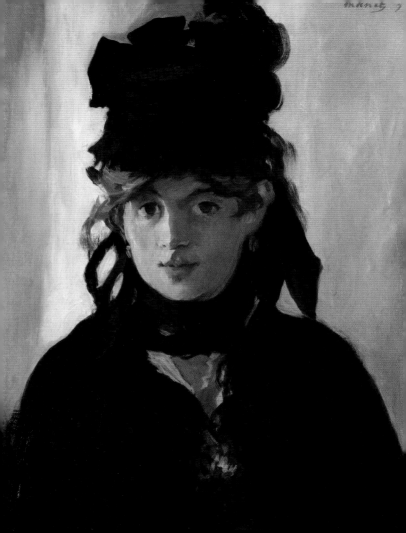

Looking at **Manet**

Émile Zola

introduced by
Robert Lethbridge

The J. Paul Getty Museum, Los Angeles

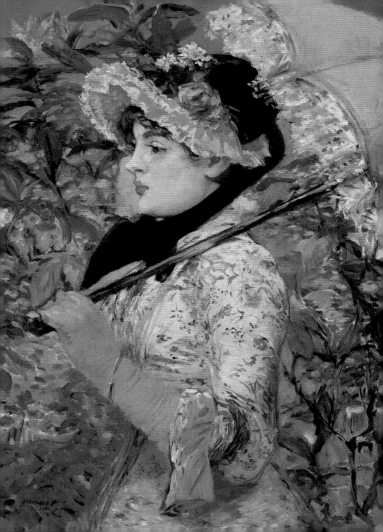

CONTENTS

Opposite: Jeanne (Spring), 1881

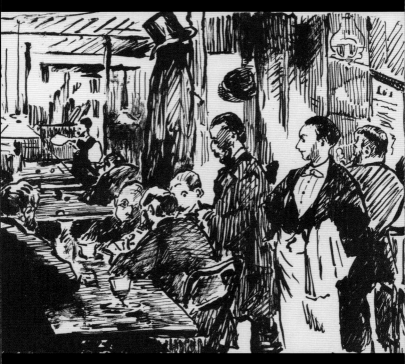

Le Café Guerbois ('At the Café Guerbois'), 1869

INTRODUCTION

ROBERT LETHBRIDGE

Émile Zola (1840-1902) was once considered the lead-
ing European novelist of his generation. Of his twenty-
volume Rougon-Macquart cycle (1871-92), works like
L'Assommoir (1877) and *Germinal* (1885), with their
brutally realistic description of working-class life, re-
main classics of 19th-century fiction. The judgments of
posterity, however, should not obscure the fact that, to
contemporaries, Zola was also known as a prominent
journalist and art critic. Many novelists and poets simul-
taneously wrote for the newspapers, particularly as a way
of earning a living at the beginning of their careers. Only
a very small number focused directly on the visual arts.
In Zola's case, such an interest was largely as a result of
personal connections. It was sparked by sharing a child-
hood and schooldays with Cézanne in Aix-en-Provence.
From 1866 onwards, he was part of a group of young
artists who met at the Café Guerbois in the Batignolles
district of Paris. They included some of the major figures
of the Impressionist movement. And it is not by chance
that, in Henri Fantin-Latour's *Un atelier aux Batignolles*
of 1870 (Musée d'Orsay, Paris), Manet at his easel is

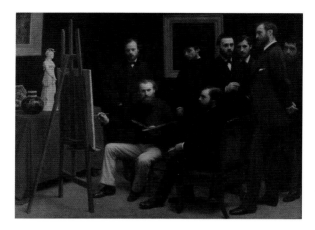

A Studio in the Batignolles Quarter (1870) by Henri Fantin-Latour. Manet, seated, painting Zacharie Astruc; standing, left to right, Otto Scholderer, Auguste Renoir, Émile Zola, Edmond Maître, Frédéric Bazille and Claude Monet

surrounded not only by Monet, Renoir and others such as Frédéric Bazille (who would have become no less famous had he survived the Franco-Prussian War), but also – as the sole professional writer in the painter's circle – by Zola himself. This is equally true, in the same year, of Bazille's *L'Atelier de la rue de la Condamine* (Musée d'Orsay, Paris), in which Zola is depicted in similar company. What also sets him apart is the fact that his writing

on painting is sustained over three decades. A number of his own novels include fictional painters, culminating in *L'Œuvre* (1886) which, with its composite portraits and reconfigured art-criticism, represents a summa of Zola's long engagement with the painters of his time.

Among these, Manet's place is an exceptional one. Even in his very last essay on painting, in 1896, Zola repeated that he remained the most significant painter of the period. Manet was the artist whose work received Zola's most refined critical reflection, deepened through the contacts afforded by a lifelong personal friendship. At Manet's death in 1883, at the tragically early age of 51, Zola was one of the pall-bearers at his funeral. But, in the years 1866-68, the most striking feature of his writing on Manet is the way in which commentary becomes an apologia for the critic. There is no reason to doubt the sincerity of Zola's views of Manet's wonderful talent; but neither would it be unfair to suggest that his art criticism was designed to further his own reputation and proclaim his own æsthetic principles (at the crucial moment prior to embarking on *Les Rougon-Macquart*) as much as those of the painter. In choosing to defend an artist as controversial as Manet, Zola successfully obtained for himself what he considered to be the enviable notoriety already achieved by the painter. Manet, by contrast, was an unwilling leader of an embryonic

avant-garde. It was perceived as such by virtue of submissions rejected by the annual Salon (which, with its commissions and prizes, could make or break an artistic career), and in particular by the Salon des Refusés ('Salon of the Rejects') of 1863, which included three of his paintings, amongst them *Le déjeuner sur l'herbe* (Musée d'Orsay, Paris, reproduced pp. 70-71). Many of his works during the 1860s had been greeted with hilarity and incomprehension by the critical establishment. For Zola, his was the perfect cause to champion.

In his extended study of Manet, published in the *Revue du XIXe siècle* on 1 January 1867 and reproduced here (pp. 21-102), and even more so in a precursor Salon article devoted to Manet (*L'Evénement*, 7 May 1866), Zola takes the opportunity to write about himself, both directly and by implication. In the press, he underlines his own audacity and courage as a critic in daring to attack the arbiters of public taste, and refers to the hostility he will incur as a result of his admiration for Manet's work. In his less aggressive *Édouard Manet, étude biographique et critique*, he explicitly prefigures the 'book which I propose to write on my artistic beliefs' (p. 45). His references to Manet as an 'analytical painter' are grounded in the same pseudoscientific jargon characteristic of his own emerging Naturalism. And the consistent recourse to the notion of the painter's 'language' is itself revealing. He

allows Manet his apprenticeship – Couture, *Le buveur d'absinthe* (1859, Ny Carlsberg Glyptotek, Copenhagen, p. 31) and his 'Spanish phase' exemplified by *L'enfant à l'épée* (1861, Metropolitan Museum of Art, New York, p. 61) – but reserves his praise for a 'unity' synonymous with 'originality', of which the unspoken model is Zola himself. But there is also a forward-looking optimism inseparable from his valuation of a 'solidity' (of 'masses' and simplified contrasts through Manet's suppression of intermediate semi-tones) equally applicable to the writer's own compositional practice. At this stage, he expresses his confidence in both their future places in the pantheon of art. His later disappointment with Manet coincides with the painter's subsequent further development, in the fractured brushwork of his more properly Impressionist pictures of the 1870s, at odds with Zola's theoretical priorities. And it explains why Manet, viewed from the preface to his 1884 retrospective (pp. 113-39), is considered a transitional figure ('pointing the way to others') in Zola's narrative of the modernist advance.

His own seminal role in positioning Manet within that narrative occupies such a celebrated chapter in the histories of nineteenth-century French art that both the insights and limitations of his writing on individual paintings are too seldom situated in the polemical context that determines his focus. His 1867 study is overtly

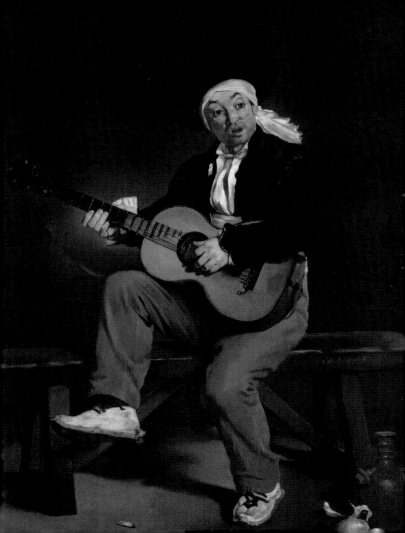

generated by a visit to Manet's studio during which he saw between 30 and 40 canvases originally being prepared for the Universal Exhibition. In practice, Zola only considers in any detail 15 of the 56 works ultimately shown at the painter's alternative exhibition at the Avenue de l'Alma (literally) opposite the official one. The vast majority of those singled out for discussion can be correlated – and even in the space allocated to each of them – to the hostility, either registered or anticipated – of their reception, thereby justifying the final section of the study devoted to a diatribe against the philistinism of 'The Public'. The paragraphs on *La musique aux Tuileries* (1862, National Gallery, London, pp. 66-67) and *Le Christ mort et les anges* (1864, Metropolitan Museum of Art, New York, p. 75) evoke the negative reactions to them, notwithstanding the latter's successful submission to the Salon of 1865. Zola claims to like *Le joueur de fifre* (Musée d'Orsay, Paris, p. 82), rejected in 1866. Those accepted, like *Le chanteur espagnol* (1860, Metropolitan Museum of Art, New York) or *Jésus Insulté par les Soldats* (1864, Art Institute of Chicago), generally serve his purpose less well.

Integral to that purpose is Zola's more wide-ranging opposition to the imperial regime of Napoleon III, as

Opposite: Le chanteur espagnol, 1860

his reference (at the beginning of his January study) to its 'orderly police state' (p. 29) makes clear. Even art criticism, contemptuous of officially sanctioned works and genres, is thereby politically informed. The provocative association of his name with Manet's continued throughout 1867, to the extent that the latter is described, in the anti-republican columns of *L'Univers illustré*, as 'the Zola of painting'! Manet hesitated before approving Zola's suggestion to republish his study in brochure form to coincide with the opening, on 24 May, of his private exhibition, almost certainly because of unease about such blatant exercises in publicity. A further opportunity to exploit the occasion lay in Zola's efforts to secure from Manet drawings to illustrate a new edition of his *Contes à Ninon* (1864). Success was assured, he promised his publisher, owing to Manet's notoriety and the virulent response to the exhibition. Though this project finally came to nothing (its residual trace is the dedication to Manet of his 1868 novel *Madeleine Férat*), Manet repaid Zola for his efforts by agreeing to paint his portrait. Zola sat for this between November 1867 and February 1868, and it was exhibited at the annual Salon a few months later.

It was now Manet's turn to present Zola to the public. In that sense, the painting had the same tactical function as Zola's earlier pen-portrait of Manet, designed to

counter the popular misconception of the artist as a 'Bo-hemian' and 'slovenly dauber' (p. 27). In its general con-ception and internal reference to Zola's 1867 study of the painter (the title on its blue cover serving as Manet's sig-nature), the portrait testified not only to their friendship but also, like Fantin-Latour's grouping of contemporary artists, to a common commitment to a new æsthetic pro-gramme. At the same time, however, the painting has been cited as evidence of Manet's penchant for calling attention to himself in concealed but insistent ways, and is therefore not unlike the less discreet self-advertisement present in Zola's earlier studies of the artist. For if the portrait provided a corrective to Zola's image in the eyes of conservative critics, it has also been argued that Manet unconsciously transferred to his subject a large measure of his own physical distinction and sartorial elegance.

Of the painting's compositional elements that refer directly to particular aspects of Zola's interpretation of Manet's art, none is more telling than the reproduction of *Olympia* (1863, Musée d'Orsay, Paris; see pp. 1 & 104) within it. In wittily turning the courtesan's gaze towards the writer at his desk, Manet seems to declare both his own appreciation, and Olympia's acknowledgement, of Zola's efforts to defend her reputation. For this painting, violently attacked on both æsthetic and moral grounds at the Salon of 1865, was, in Zola's words, 'Manet's

masterpiece' (p. 74). In his analysis of it are to be found some of the most perceptive pages of Zola's art criticism. On the other hand, much of the portrait's iconography suggests that Manet was also pointing to a complexity in his own art that Zola had not really understood.

For Zola's critical perspective is informed by contradiction. He is at pains to rebut charges of immorality by insisting that *Olympia* is devoid of meaning. He tries to move the debate away from its 'scandalous' subject by arguing that the picture is merely a structure of colours. That same emphasis is to be found in his presentation of *Le déjeuner sur l'herbe*, in which the human figures are considered as being subordinate to tonal imperatives. And Zola thereby initiates the purely formalist approach to Manet's art that has been so influential since. Awkwardly juxtaposed, however, is his emphasis on those realistic features of Olympia subverting the traditions and pictorial euphemisms of the female nude across the centuries. Nowhere is this more problematic than in his untenable dismissal of affinities between Baudelaire and Manet, brought into sharpest relief by Zola's devaluation of Olympia's cat (viewed by the critics as the painting's most outrageously erotic marker) as having no other function than providing a counterbalancing black stain at the right-hand edge of the painting. In Zola's *Thérèse Raquin*, prepared at precisely the same time as

his reflections on *Olympia*, it is possible to discern numerous analogies of theme and technique, not least his own Baudelairean substitutions of the female and the feline in the shape of a black cat associated with the sexual vicissitudes of the novel's plot. Together with its fictional painter (whose work obliquely recalls Manet's), described as a 'poet', the text's symbolic register may itself testify to a sensitivity to Manet for which Zola is seldom given credit, so prevalent are the orthodoxies of his public statements.

What is certain is that Zola, more than any other writer of the period, enjoys a set of interchanges with Manet notable for their creative and critical importance. Both contemporaries and modern art historians, whether or not in agreement with his emphases, accord Zola the pre-eminence he deserves in directing attention to Manet's modernity and greatness. And those interchanges go both ways. Manet's *Nana* of 1877 (Kunsthalle, Hamburg, illustrated overleaf), to take only one example, was clearly inspired by an episode in *L'Assommoir* in which the heroine's daughter, also called Nana, starts her life as a prostitute; and Zola's *Nana* (1880) has two scenes that almost exactly replicate Manet's painting. In *L'Œuvre*, Zola has fully exploited his familiarity with Manet's life and work. Authorial nostalgia for the militant solidarity of the late 1860s is

overlaid by an ironic distance from those heroic struggles. More generally, Zola's own review of his 1868 portrait (pp. 103-12) is perhaps symptomatic of a mirroring relationship, sometimes distorted by the tensions between identification and the differences between writing and painting. Zola seems oblivious to the implications of his blank stare, the fallen pince-nez without which he could not see and his apparent blindness to the visual objects on display: these range from Velázquez to Japanese prints and the volume of Charles Blanc's *Histoire des peintres de toutes les écoles* at its centre, all of them essential components of Manet's art that Zola had failed to mention in his commentary and that eloquently refute his denial of the painter's intentionality. But, on the other hand, Zola was given the portrait by Manet and it continued to occupy pride of place in his various homes. Towards the end of his life, he even experimented in photographing it, thus completing the self-conscious patterning, across the years, of Zola looking at Manet looking at him.

Opposite: Nana, 1877

Overleaf: Madame Auguste Manet, 1863

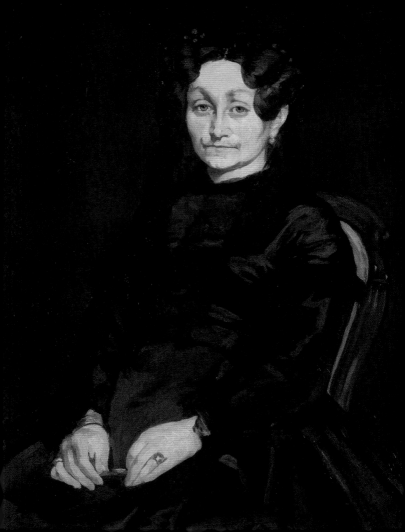

A new way to paint:
Édouard Manet

1867

Before this study appeared in book form in Mes Haines, *it was published on 1 January 1867 in the* Revue du XIX Siècle *(edited by Arsène Houssaye), under the title of 'Une nouvelle manière de peindre: Édouard Manet'; then it appeared for a second time in brochure form. Zola undertook this eulogy of Manet after visiting the artist's studio. Zola had already expressed his enthusiasm for Manet's innovating talent in an article in* L'Evénement *of 7 May 1866, which had brought De Villemessant's journal a quantity of letters of protest from indignant readers. De Villemessant responded on 14 May with an article entitled 'Justice de la Paix de l'Evénement', which gave his own views on the scandal. Now that there was talk of a new religion of which Manet was the God and Zola the prophet, De Villemessant announced that Théodore Pelloquet, a 'specialist', would write three articles in his newspaper for those people who did not like Manet's painting, which would act as a 'corrective and counter-balance' to Zola's three articles. Between these two 'judgments', Solomon-De Villemessant concluded, the public would be free to take their choice. But Zola, disapproving of this 'sharing out', resigned from the paper.*

It is a delicate task to establish bit by bit the personality of an artist. Such a labour is always difficult and it is really only possible to give a complete and truthful picture when a man's life work is already achieved – when he has already given all that is expected of his talent. In that case the whole can be analysed; every aspect of his genius can be studied, a precise and exact portrait can be drawn, without fear of losing sight of certain characteristics. In this case the critic gets the most profound pleasure in saying to himself that he can now dissect an individual; that it is a question of the anatomy of an organism; and that later he will be able to reconstruct, as in real life, a man in possession of all his limbs, all his nerves, all his heart, all his dreams and all his senses.

But on studying the painter Manet, today, I cannot taste such joys. The first outstanding works of the artist are not more than six or seven years old. I would not be able to pass a final judgment on him from the thirty or forty canvases which I have been allowed to see and appreciate. Here there is no question of arrested development; the painter has reached that restless age when his talent is developing and growing. Up to now he has no doubt developed only one side of his personality; too much lies ahead

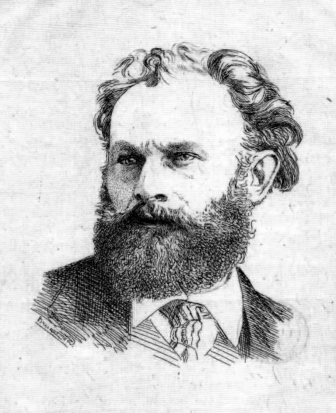

of him, too much future; he runs too many risks of all sorts for me to attempt to sum up in these pages his portrait in one definitive stroke.

I certainly would never have undertaken to trace the simple silhouette that I am now allowed to present, if I had not been moved to do so by particular and strong reasons.

Circumstances have made Édouard Manet, who is quite young, into a most unusual and instructive subject for study. The very odd place which the public – and even the critics and his artist colleagues – have accorded him in contemporary art struck me as something which should be carefully studied and explained. And here it is not only the personality of Édouard Manet that I am trying to analyse, but the whole of our artistic movement itself and contemporary opinion on æsthetics.

A curious situation has arisen, and this situation can be summed up in two words. A young painter has obeyed, in a very straightforward manner, his own personal inclinations concerning vision and understanding; he has begun to paint in a way which is contrary to the sacred rules taught in schools. Thus, he has produced original works, strong and

Opposite: Édouard Manet, 1867, by Félix Bracquemond, used as frontispiece to the pamphlet edition of Zola's essay

bitter in flavour, which have offended the eyes of people accustomed to other points of view. And now you find that these same people, without trying to understand why their eyes have been offended, abuse this painter, insult his integrity and talent; and have turned him into a sort of grotesque lay-figure who sticks out his tongue to amuse fools.

Isn't such a commotion an interesting subject for study? Isn't it a reason for an inquisitive, unbiased man like myself to halt on his way in the presence of the mocking, noisy crowds which surround the young painter and pursue him with their hoots of derision?

I picture myself in the middle of a road where I meet a gang of young ruffians who are throwing brick-bats at Édouard Manet. The art critics – pardon, I mean the police – are not doing their job well. They encourage the row instead of calming it down, and even – may God forgive me! – it looks as though the policemen themselves have enormous brick-bats in their hands. Already, it seems to me, there is something decidedly unpleasant about this scene which saddens me – me a disinterested passer-by, calm and unbiased.

I go up to the ruffians and question them; I question the police, I even question Édouard Manet himself. And I become more and more convinced about

something. The reason for the anger of the young ruffians and the weakness of the police is explained to me. I am given to understand what crime it is that this pariah whom they are stoning has committed. I go home and prepare, for the sake of truth, the official evidence which you are about to read.

Obviously, I have only one object in mind – to calm down the blind anger of the rowdies and to try to make them return to a more common-sense point of view, and, at all costs, to stop them making such a din in the street. I ask them not only to criticize Édouard Manet fairly but also *all* original artists who will make their appearance. I extend my plea further – my aim is not only to have one man accepted, but to have all art accepted.

Taking Édouard Manet's case as typical of the way really original personalities are received by the public, I protest against this reception, and from the individual I proceed to a question which touches all real artists.

This article, I repeat, for several reasons, will not be a definitive portrait. It is a simple summary of the existing state of affairs. It is an offical account of the regrettable influence – as it seems to me – that centuries of tradition have had on the public as far as art is concerned.

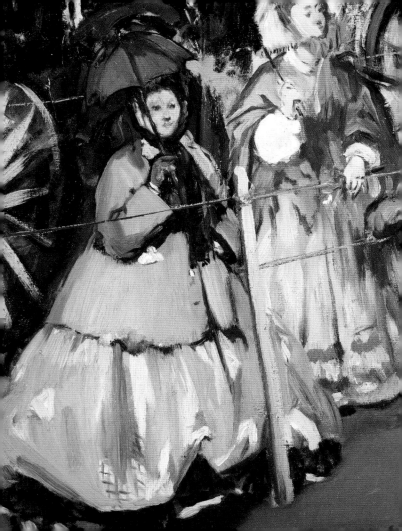

I. THE MAN
AND THE ARTIST

Édouard Manet was born in Paris in 1833. I have only a few biographical details concerning him. In this orderly police state of ours, an artist's life is the same as that of any quiet bourgeois; he paints his pictures in his studio as others sell pepper over their counters. The long-haired types of 1830, thank heavens, have completely disappeared, and our painters have become what they ought to be – people living the same life as everyone else.

After spending some years with the Abbé Poiloup at Vaugirard, Édouard Manet finished his education at the Collège Rollin. At the age of seventeen, on leaving college, he fell in love with painting. What a terrible love that is – parents tolerate a mistress, even two; they will close their eyes if necessary to a straying heart and senses. But the Arts! Painting for them is the Scarlet Woman, the Courtesan, always hungry for flesh, who must drink the blood of their children, who clutches them, panting, to her insatiable lips.

Opposite: Femmes à la course, 1866

Here is Orgy unforgivable, Debauchery – the bloody spectre which appears sometimes in the midst of families and upsets the peace of the domestic hearth.

So, of course, at the age of seventeen, Édouard Manet was embarked as a cadet on a ship bound for Rio de Janeiro. Undoubtedly, the Scarlet Woman, that Courtesan, always hungry for fresh blood, embarked with him, and surrounded by the clear, empty vastness of sky and ocean, succeeded in seducing him. She appealed to his flesh, she dangled before his eyes sparkling horizons and spoke to him of passion, in the sweet and compelling language of colour. On his return, Manet was given up entirely to Infamy.

He quit the sea and visited Italy and Holland. But he had not yet found his feet; he wandered around like a young innocent and wasted his time. As evidence of this, he entered the studio of Thomas Couture as a pupil, and stayed there for nearly six years, his hands tied by precepts and counsels, wallowing in complete mediocrity, not knowing how to find his way.

There was a particular trait in his make-up, which prevented him from accepting these first lessons, but the influence of this artistic education, which went against his natural inclination, had an effect on his

Opposite: Le buveur d'absinthe, 1858-59

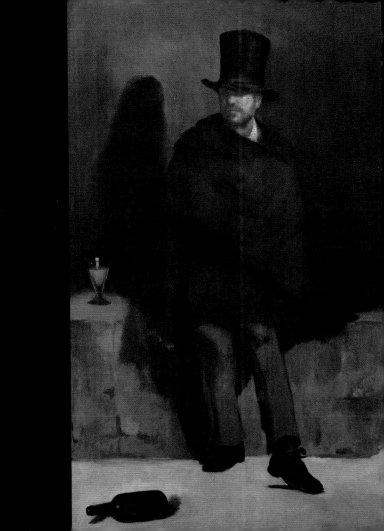

work, even after he had left the master's studio. For three years, he fought in the dark, he worked without quite understanding what he was seeing, nor what he wanted to do. It was only in 1860 that he painted *Le buveur d'absinthe*[1] – a canvas in which there are still traces of the works of Thomas Couture, but which already contains a germ of the artist's own personal manner.

His artistic life, after 1860, is known to the public. The strange impression made by several of his canvases in the Martinet Exhibition and in the Salon des Refusés in 1863 will be remembered. It will also be recalled what a hubbub was occasioned by his paintings *Le Christ mort et les anges*[2] and *Olympia*[3] in the Salons of 1864 and 1865. In making a study of his works, I will return to that period of his life.

Édouard Manet is of average height, more short than tall. His hair and beard are pale chestnut; his eyes which are narrow and deep-set are full of life and youthful fire; his mouth is characteristic, thin and mobile and slightly mocking in the corners. The whole of his good-looking, irregular and intelligent

1. 'The Absinthe Drinker', 1858-59, Ny Carlsberg Glyptotek, Copenhagen, ill. p. 31 2. 'The Dead Christ with Angels', 1864, Metropolitan Museum of Art, New York, ill. p. 75 3. 1865, Musée d'Orsay, Paris, ill. pp. 78-79

features proclaim a character both subtle and coura-
geous, and a disdain for stupidity and banality. And
if we leave his face for his person, we find in Édouard
Manet a man of extreme amiability and exquisite
politeness, with a distinguished manner and a sym-
pathetic appearance.

I am absolutely obliged to insist on these utterly
minor details; because contemporary fools, who earn
their living by making the public laugh, have turned
Manet into a sort of Bohemian character, a rogue, a
ridiculous bogey, and the public has accepted the
jokes and the caricatures as so much truth. The truth
is far removed from these dummies, created in the
imagination of penny-a-line humorists, and it is in
order to present the real man that I write these lines.

The artist has confessed to me that he adores soci-
ety and that he found secret pleasure in the perfumed
and glittering refinement of soirées. He was drawn to
them by his love of bold and vivid colour; but, in his
heart of hearts he had an innate need for refinement
and elegance which I try hard to find in his works.

Such, then, is his life. He works assiduously and
the number of his canvases is already considerable.
He paints without getting discouraged; without
wearying; marching forward according to his own
lights. Then he returns to his home and there tastes

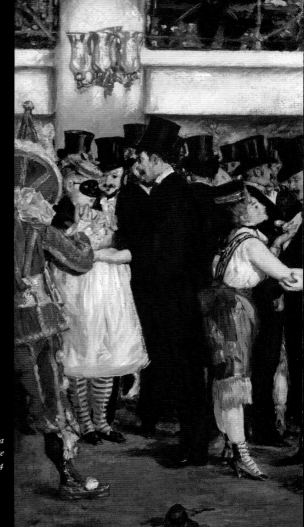

Bal masqué à l'Opéra ('Masked Ball at the Opéra'), 1873-74

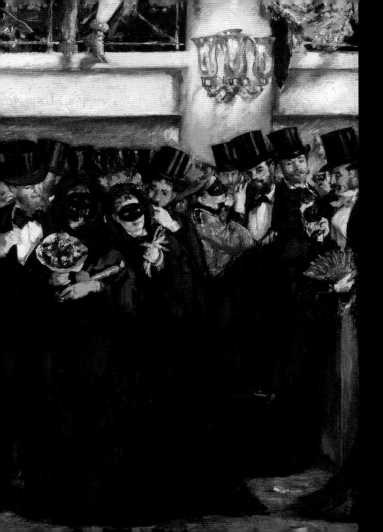

the quiet pleasures of the modern bourgeois. He goes out a great deal, following the same sort of life as most people, but perhaps with this difference, that he is more quiet and cultivated than the majority.

I really had to write these lines before speaking of Manet as an artist. I feel it is much easier now to tell people who are already prejudiced what I believe to be the truth. I hope that people will cease to treat this man, whose portrait I have attempted to trace in a few lines, as a slovenly dauber, and that they will pay polite attention to the unbiased opinions which I am going to give on a sincere and dedicated artist.

I am certain that the true aspect of the real Manet will surprise many people; he will be judged, henceforth, with less irreverent laughter and with more becoming attention. The question resolves itself to this: there is no doubt that the painter paints in a completely unaffected and calculated manner, and it is only a question of knowing whether he is producing works of talent or whether he is grossly deceiving himself.

I would not like to lay down the principle, as an argument in favour of Édouard Manet, that because he wasted his time at Thomas Couture's, a student's failure to follow the teaching of his master is a mark of genius. In the career of every artist, there is necessarily a period of groping and hesitation which

lasts, more or less, for a long time; it is admitted that each artist must pass through this period in the studio of a professor, and I see no harm in that. The advice received here, even though it may, to begin with, prevent the expression of original talent, does not prevent this talent from eventually manifesting itself; the studio influence will sooner or later be quite forgotten so long as the artist has individuality and perseverance.

But in the present case, it pleases me to regard Édouard Manet's long and difficult apprenticeship as a symptom of originality. It would be a long list if I was to mention here all those artists who were discouraged by their masters and who later became men of the greatest merit. 'You will never succeed in doing anything,' says the teacher, which no doubt means, 'Without me there is no hope, and you are not me.' Happy pupils who are not recognized by the masters as their children! They are a race apart, each one adds his word to the great sentence which humanity writes and which will never be complete. They are destined themselves in their own turn to be masters, egoists set in their own opinions.

Édouard Manet tried to find his own way and see for himself.

He spoke in a language full of harshness and grace

which thoroughly alarmed the public. I do not claim that it was an entirely new language and that it did not contain some Spanish turns of phrase (about which moreover I will have to make some explanation). But judging by the forcefulness and truth of certain pictures, it was clear that an artist had been born to us. He spoke a language which he had made his own, and which henceforth belonged entirely to him.

This is how I explain the birth of a true artist, Édouard Manet, for example. Feeling that he was making no progress by copying the masters, or by painting Nature as seen through the eyes of individuals who differed in character from himself, he came to understand, quite naturally, one fine day, that it only remained to him to see Nature as it really is, without looking at the works or studying the opinions of others. From the moment he conceived this idea, he took some object, person or thing, placed it at the end of his studio and began to reproduce it on his canvas in accordance with his own outlook and understanding. He made an effort to forget everything he had learned in museums; he tried to forget all the advice that he had been given and all the paintings that he had ever seen. All that remained was a singular gifted intelligence in the presence of Nature, translating it in his own manner.

Thus the artist produced an œuvre which was his own flesh and blood. Certainly, this work was linked with the great family of works already created by mankind; it resembled, more or less, certain among them. But it had in a high degree its own beauty – I should say vitality and personal quality. The different components, taken perhaps from here and there, of which it was composed, combined to produce a completely new flavour and personal point of view; and this combination, created for the first time, was an aspect of things hitherto unknown to human genius. From then onwards Manet found his direction; or to put it better, he had found himself. He was seeing things with his own eyes, and in each of his canvases he was able to give us a translation of Nature in that original language which he had just found in himself.

And now, I beg the reader, who has been kind enough to follow me thus far and who is willing to understand me, to look at things from the only logical point of view by which a work of art can be judged properly. Without doing so, we will never understand each other. He would only stick to his prejudices, while I would propound quite different axioms, and so we would go on, becoming more and more separated from each other. On reaching the last line of this article he would regard me as a fool,

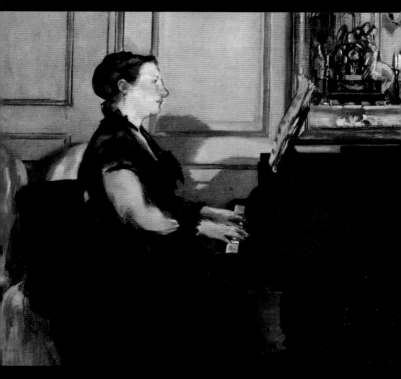

Madame Manet au piano
(*'Madame Manet at the piano'*),
1867-68

and I would regard him as a man of little intelligence. We must proceed as the artist himself proceeded; we must forget the treasures of museums, and the necessity of obeying so-called laws; we must banish from our memory the accumulated pictures of dead painters. We must only see Nature face to face, Nature as it really is. We must look, in fact, for nothing more in the works of Édouard Manet than a translation of reality, peculiar to his own outlook and full of human interest.

I am forced here, to my greatest regret, to set forth some general ideas. My æsthetic, or rather the science which I will call 'the modern æsthetic', differs too much from the dogma which has been taught up till now, to risk speaking without making myself perfectly clear.

Here is the popular opinion concerning art. There is an 'absolute' of beauty which is regarded as something outside the artist or, to express it better, there is a perfect ideal for which every artist reaches out, and which he attains more or less successfully. From this it is assumed that there is a common denominator of beauty. This common denominator is applied to every picture produced, and according to how far the work approaches or recedes from this common denominator, the work is declared good or less good.

Circumstances have elected that the Classical Greek should be regarded as the standard of beauty, so that all works of art created by mankind have ever since been judged on their greater or lesser resemblance to Greek works of art.

So here you see the whole output of human genius, which is always in a state of rebirth, reduced to terms of the simple flowering of Greek genius. The artists of this country have discovered the 'absolute' of beauty and thereafter all has been already said. The common denominator having been fixed, it is only a question of imitating and reproducing the original models as exactly as possible. There are some people who will insist that the artists of the Renaissance are very great because they were imitators. For two thousand years the world has been constantly changing, civilizations have flourished and crumbled, society has advanced or languished in the midst of ever-changing customs; on the other hand, artists are born here or there, on pale, cold mornings in Holland, or in the warm, voluptuous evenings of Italy and Spain – but what of that! The 'absolute' of beauty is there, unchangeable, dominating the centuries. All life, all passions, all that creative energy which has enjoyed itself and suffered for two thousand years is miserably crushed under this idea.

Here, then, is what I believe concerning art. I embrace all humanity that has ever lived and which at all times, in all climates, under all circumstances, has felt, in the presence of Nature, an imperious need to create and reproduce objects and people by means of the arts. Thus I have a vast panorama, each part of which interests and moves me profoundly. Every great artist who comes to the fore gives us a new and personal vision of Nature. Here 'reality' is the fixed element, and it is the differences in outlook of the artists which has given to works of art their individual characteristics. For me, it is the different outlooks, the constantly changing viewpoints, that give works of art their tremendous human interest. I would like all the pictures of all the painters in the world to be assembled in one vast hall where, picture by picture, we would be able to read the epic of human creation. The theme would always be this self-same 'nature', this self-same 'reality' and the variations on the theme would be achieved by the individual and original methods by which artists depict God's great creation. In order to pronounce fair judgment on works of art, the public should stand in the middle of the vast hall. Here beauty is no longer 'absolute' – a ridiculous common denominator. Beauty becomes human life itself; the

human element, mixed with the fixed element of 'reality' giving birth to a creation which belongs to mankind. Beauty lies within us, and not without. What is the use of philosophic abstractions! Of what use is a perfection dreamed up by a little group of men! It is humanity that interests me. What moves me, what gives me exquisite pleasure is to find in each of the creations of man an artist, a brother, who shows me with all his strength and with all his tenderness the face of Nature under a different guise.

A work of art, seen in this way, tells me the story of flesh and blood; it speaks to me of civilizations and of countries. And when in the midst of the vast hall I cast an eye over the immense collection, I see before me the same poem in a thousand different languages, and I never tire of re-reading it in each different picture, enchanted by the delivery or strength of each dialect.

I cannot give you here, in its entirety, the contents of the book which I propose to write on my artistic beliefs, and I content myself with giving only a broad outline. I overthrow no idols – I do not abjure any artist. I accept all works of art under the same title, the title of the manifestation of human genius. They all interest me almost equally; they all possess true beauty and life – life in its thousand different

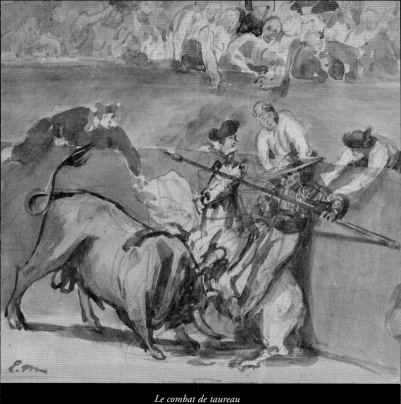

Le combat de taureau
(*'Bullfight'*), 1877

expressions, always changing, always new. The ridiculous common denominator does not exist any more: the critic studies a picture for what it is, and pronounces it a great work when he finds in it a vital and original interpretation of reality. He can then state that to the genesis of human creation another page has been added; that an artist has been born who has given Nature a new soul and new horizons. Our creation stretches from the past into an infinite future. Every society will produce its artists, who will bring with them their own points of view. No systems, no theories can hold back life in these unceasing productions.

Our task then, as judges of art, is limited to establishing the language and the characters; to study the languages and to say what new subtlety and energy they possess. The philosophers, if necessary, will take it on themselves to draw up formulas. I only want to analyse facts, and works of art are nothing but simple facts.

Thus I put the past on one side – I have no rules or standards – I stand in front of Édouard Manet's pictures as if I were standing in front of something quite new which I wish to explain and comment upon.

What first strikes me in these pictures, is how true is the delicate relationship of tone values. Let me

explain. Some fruit is placed on a table and stands out against a grey background. Between the fruit, according to whether they are nearer or further away, there are gradations of colour producing a complete scale of tints. If you start with a 'note' which is lighter than the real note, you must paint the whole in a lighter key; and the contrary is true if you start with a note which is lower in tone. Here is what I believe is called 'the law of values'. I know of scarcely anyone of the modern school, with the exception of Corot, Courbet and Édouard Manet, who constantly obeys this law when painting people. Their works gain thereby a singular precision, great truth and an appearance of great charm.

Manet usually paints in a higher key than is actually the case in Nature. His paintings are light in tone, luminous and pale throughout. An abundance of pure light gently illuminates his subjects. There is not the slightest forced effect here; people and landscapes are bathed in a sort of gay transluscence which permeates the whole canvas.

What strikes me is due to the exact observation of the law of tone values. The artist, confronted with some subject or other, allows himself to be guided by his eyes which perceive this subject in terms of broad colours which control each other. A head posed

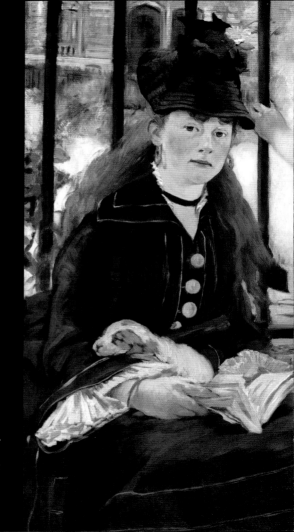

*Gare St Lazare
('St Lazare Station'),
1872-73*

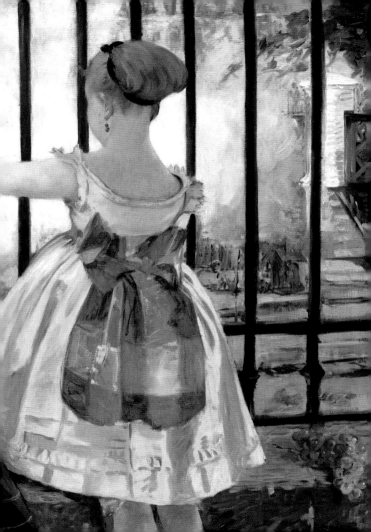

against a wall becomes only a patch of something more, or less, grey; and the clothing, in juxtaposition to the head, becomes, for example, a patch of colour which is more, or less, white. Thus a great simplicity is achieved – hardly any details, a combination of accurate and delicate patches of colour, which, from a few paces away, give the picture an impressive sense of relief.

I stress this characteristic of Édouard Manet's works, because it is their dominating feature and makes them what they are. The whole of the artist's personality consists in the way his eye functions: he sees things in terms of light, colour and masses.

What strikes me in the third place is his elegance – a little dry but charming. Let us understand each other. I am not referring to the pink and white elegance of the heads of china dolls, I am referring to a penetrating and truly human elegance. Édouard Manet is a man of the world and in his pictures there are certain exquisite lines, certain pretty and graceful attitudes which testify to his love for the elegance of the salons. Therein the unconscious element, the true nature of the painter is revealed. And here I take the opportunity to deny the existence of any relationship (as has been claimed) between the paintings of Édouard Manet and the verses of Charles

Baudelaire. I know that a lively sympathy has brought painter and poet together, but I believe that the former has never had the stupidity, like so many others, to put 'ideas' into his painting. The brief analysis of his talent which I have just made, proves with what lack of affectation he confronts Nature.

If he groups together several objects or several figures, he is only guided in his choice by a desire to obtain beautiful touches of colour and contrasts. It is ridiculous to try to turn an artist, obeying such instincts, into a mystical dreamer.

After analysis, synthesis; let us take no matter what picture by the artist, and let us not look for anything other than what is in it – some illuminated objects and living creatures. The general impression, as I have said, is of luminous clarity.

Faces in the diffused light are hewn out of simple bold patches of flesh colour; lips become simple lines; everything is simplified and stands out from the background in strong masses.

The exact interpretation of the tone values imbues the canvas with atmosphere and enhances the value of each object.

It has been said that Édouard Manet's canvases recall the 'penny-plain, twopence-coloured' pictures from Epinal. There is a lot of truth in this joke which

is in fact a compliment. Here and there the manner of working is the same, the colours are applied in broad patches, but with this difference, that the workmen of Epinal employ primary colours without bothering about values, while Édouard Manet uses many more colours and relates them exactly. It would be much more interesting to compare this simplified style of painting with Japanese engravings, which resemble Manet's work in their strange elegance and magnificent bold patches of colour.

One's first impression of a picture by Édouard Manet is that it is a trifle 'hard'. One is not accustomed to seeing reproductions of reality so simplified and so sincere. But as I have said, they possess a certain stiff but surprising elegance. To begin with one's eye only notices broad patches of colour, but soon objects become more defined and appear in their correct place.

After a few moments, the whole composition is apparent as something vigorous; and one experiences a real delight in studying this clear and serious painting which, if I may put it this way, renders Nature in a manner both gentle and harsh.

On coming close to the picture, one notices that the technique is more delicate than bold; the artist uses only a brush and that with great caution; there

is no heavy impasto, only an even coat of paint. This bold painter, who has been so hounded, works in a very calculated manner, and if his works are in any way odd, this is only due to the very personal way in which he sees and translates objects on to canvas.

In a word, if I were interrogated, if I were asked what new language Manet was speaking, I would answer, 'He speaks in a language which is composed of simplicity and truth.' The note which he strikes in his pictures is a luminous one which fills his canvas with light. The rendering which he gives us is truthful and simplified, obtained by composing his pictures in large masses.

I cannot repeat too often that, in order to understand and savour his talent, we must forget a thousand things. It is not a question, here, of seeking for an 'absolute' of beauty. The artist is neither painting history nor his soul. What is termed 'composition' does not exist for him, and he has not set himself the task of representing some abstract idea or some historical episode. And it is because of this that he should neither be judged as a moralist nor as a literary man. He should be judged simply as a painter. He treats figure subjects in just the same way as still-life subjects are treated in art schools; what I mean to say is that he groups figures more or less fortuitously,

and after that he has no other thought than to put them down on canvas as he sees them, in strong contrast to each other. Don't expect anything of him except a truthful and literal interpretation. He neither sings nor philosophizes. He knows how to paint and that is all. He has his own personal gift, which is to appreciate the delicacy of the dominant tones and to model objects and people in simplified masses. He is a child of our age. I see him as an analyst painter. All problems have been re-examined; science requires solid foundations and this has been achieved by accurate observation of facts. This approach is not confined to the world of science alone. In all branches of knowledge and in all the works of mankind, man has tended to find basic and definitive principles in reality.

Compared with our historical and genre painters, our modern landscape artists have achieved much more, because they have studied our countryside, content to interpret the first corner of a forest they came upon. Manet uses this same method in each of his works; while others break their heads trying to compose a new picture of 'The Death of Cæsar' or 'Socrates Drinking Hemlock', he quietly places some objects or poses some people in a corner of his studio and begins to paint. I repeat, he is merely an

analyst. His work is much more interesting than the plagiarisms of his colleagues. Art as practised by him leads to ultimate truth. This artist is an interpreter of things as they are, and, for me, his works have the great merit of being accurate descriptions, rendered in an original and human language.

He has been reproached for imitating the Spanish Masters. I agree that in his first works, there is a resemblance – one must be somebody's child. But after painting his *Déjeuner sur l'herbe*, he has, it seems to me, established definitely that personality which I have tried to explain and upon which I have briefly commented. Perhaps the truth is that the public, seeing him paint Spanish scenes and costumes, decided that he was taking his models from beyond the Pyrenees, and, this being the case, the accusation of plagiarism soon followed.

But it is as well to know that if Édouard Manet painted his *espada* and *majo*, it was because he had Spanish costumes in his studio and found their colours beautiful. It was only in 1865 that he travelled across Spain; his canvases are too individual in character for him to be taken as nothing more than an illegitimate child of Velázquez or Goya.

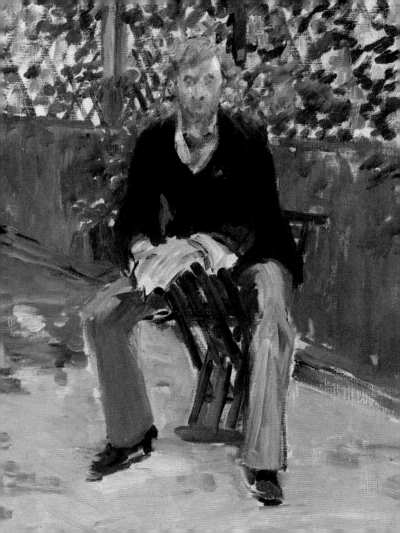

II. HIS WORKS

I will now be able, when speaking of the works of Édouard Manet, to make myself better understood. I have described in broad outline the character and talent of the artist, and each picture which I analyse will support the opinion that I have offered. His works are known and it only remains for me to explain the details which make these works what they are. In telling what I feel about each picture, I will re-establish the complete personality of the painter.

The works of Édouard Manet are already considerable. This sincere and hard-working craftsman has employed his last six years well. I would like to see something of his courage and love of work in those great scoffers who treat him as an idle rascal and leg-puller. I saw recently in his studio some thirty canvases, of which the oldest was dated 1860. He had placed them all together to see what sort of a collection they would make at the Universal Exhibition.

I hope to see them again in the Champ-de-Mars next May, and I consider that they will establish the artist's solid reputation once and for all. It is no

Opposite: George Moore dans le jardin de l'artiste,
('George Moore in the artist's garden') c. 1879

longer a question of two or three works, it is a question of thirty at least, and six years of work and talent. It is out of the question to deny the man who has been humiliated by public opinion, a brilliant 'return match' from which he will most certainly emerge victorious. The Selection Committee must understand, on this forthcoming important occasion, how stupid it would be to hide deliberately some of the most original and sincere examples of contemporary art. Rejection in this case would be veritable murder – an official assassination.

And therefore I should like to be able to take the sceptics by the hand and lead them to the pictures of Édouard Manet. 'Look and judge,' I would say. 'Behold the grotesque man, the unpopular man. He has worked for six years and here is his work. Do you still laugh at it? Do you still find it an amusing joke? You are beginning to feel, aren't you, that there is more to his talent than just black cats?

'The general effect is completely satisfying. The sincerity of his work is abundantly clear. In each canvas the artist's hand expresses the same simple and precise language. When your eye embraces all the pictures at once, you find that all these different pictures make up one whole; they represent a tremendous sum-total of analysis and vigour. Laugh once

more, if you like laughing, but take care! Henceforth you will be laughing at your own blindness.'

My first impression on entering Édouard Manet's studio was one of unity and power. One is aware of both harshness and delicacy as one first glances at the walls. Before one's attention is arrested by one particular picture, one's eyes wander from top to bottom, from right to left. These clear tones and graceful shapes, blending together, possess a harmony and a boldness of style which is both simple and extremely powerful.

Then slowly, one by one, I examine minutely each picture. Here in a few lines are my opinions on each. I stress the more important.

As I have said, the oldest is *Le buveur d'absinthe* – an emaciated and bewildered-looking man, draped in a cloak and overwhelmed by life. But I don't find here that simplicity and precision, so powerfully and broadly executed, which the artist will practice later.

Next comes *Le chanteur espagnol*[1] and *L'enfant à l'épée*[2] which were used as brick-bats to smash the painter's last works. *Le chanteur espagnol*, a Spaniard seated on a green wooden bench, singing and

1. 'The Spanish Singer', 1860, Metropolitan Museum of Art, New York, ill. p. 12 2. 'Boy with a Sword', 1861, Metropolitan Museum of Art, New York, ill. p. 61

plucking the strings of his instrument, has obtained an 'honourable mention'. *L'enfant à l'épée* is a little boy, standing with an air of innocence and astonishment, holding in his two hands an enormous sword attached to a baldrick. These paintings are firmly and solidly painted but are, at the same time, very delicate and are in no way offensive to the feeble view-point of the public. It has been said that Édouard Manet has a certain affinity with the Spanish Masters, and he has never acknowledged the fact so potently as in *L'enfant à l'épée*. The head of the little boy is a marvel of modelling and restrained strength. If the artist had always painted similar heads, he would have been the darling of the public, overwhelmed with praise and money. It is true that he would have remained merely a reflection, and we would never have known his talent for beautiful simplicity. As far as I am concerned I must admit that my sympathies lie elsewhere among the painter's works. I prefer the fresh crispness and the exact and strong masses of his *Olympia* to the carefully studied niceties of *L'enfant à l'épée*. But from now onwards I am only going to speak of the pictures which seem to me to be the flesh and blood of Édouard Manet. To begin with there are the pictures of 1863 which,

Opposite: L'enfant à l'épée, 1861

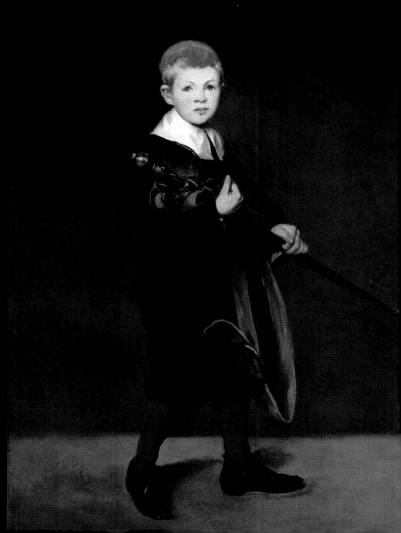

when exhibited at Martinet's in the Boulevard des Italiens, caused a veritable uproar. As usual, hissing and cat-calls announced the fact that a new and original artist had just revealed himself. There were fourteen pictures exhibited; we will find them again at the Universal Exhibition: *Le vieux musicien*,[1] *Le liseur*,[2] *Les gitanos*,[3] *Un gamin*,[4] *Lola de Valence*,[5] *La chanteuse des rues*,[6] *Le ballet espagnol*[7] and *La musique aux Tuileries*.[8]

I will content myself with discussing the first four. As far as *Lola de Valence* is concerned, she is extolled in Charles Baudelaire's quatrain which was hissed and treated in much the same way as the picture itself:

> Entre tant de beautés que partout on peut voir,
> Je comprends bien, amis, que le désir balance
> Mais on voit scintiller dans Lola de Valence
> Le charme inattendu d'un bijou rose et noir.*

*Between the many beauties one can see anywhere / how desire can hesitate, friends, I understand / But in Lola de Valence glitters / the unexpected charm of a jewel both rose-coloured and black.

1. 'The Old Musician', 1861-62, National Gallery of Art, Washington, DC 2. 'The Reader', St Louis Art Museum 3. 'The Gypsies', 1862. Cut up by Manet; three fragments survive and the composition is recorded in an etching dated 1862 4. 'A Scamp', 1860-61, Private Collection, Paris 5. 1862, Musée d'Orsay, Paris 6. 'The Street Singer', c. 1862, Museum of Fine Arts, Boston, ill. p. 64 7. 'The Spanish Ballet', 1862, Phillips Collection, Washington, DC 8. 'Music in the Tuileries Gardens', 1862, National Gallery, London, ill. pp. 66-67

Opposite: Lola de Valence, 1862

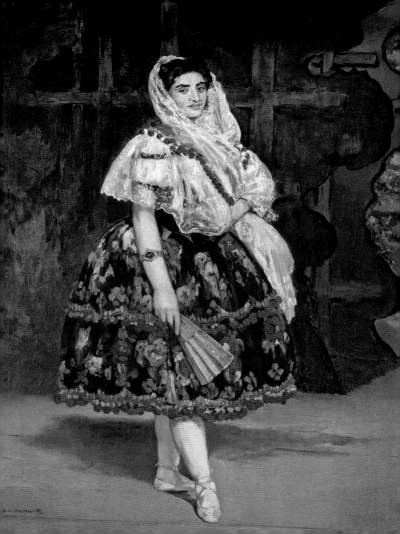

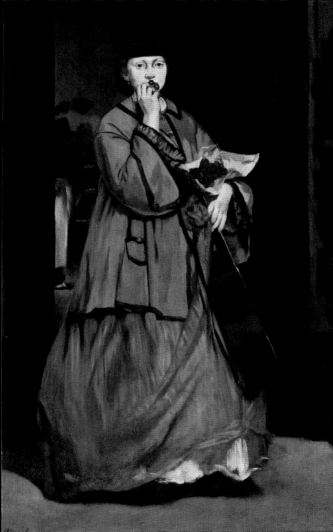

I don't pretend to defend this verse but, for me, it has the great merit of summing up in rhyme the whole of the artist's individuality. It is perfectly true that *Lola de Valence* is a 'bijou rose et noir'. The painter by now is already working only in masses and his Spanish woman is painted largely in bold contrasts. The whole canvas is painted in only two tones.

The picture which I prefer amongst those I have just named is *La chanteuse des rues*. A young woman, well known on the heights of the Panthéon, is making her exit from a brasserie, eating cherries which she holds in a sheet of paper. The whole work is in a soft pale grey. The subject here seems to me to have been analysed with extreme simplicity and accuracy. A work such as this has, apart from its subject, a dignity which makes it appear larger than it really is. One is aware of the search for truth and the conscientiousness of a man who, above all, is setting down honestly what he sees.

It was the two other pictures, *Le ballet espagnol* and *La musique aux Tuileries* which put flame to the powder. An exasperated picture lover went so far as to threaten that if *La musique aux Tuileries* was left any longer in

Opposite: La chanteuse des rues, c. 1862

Overleaf: La musique aux Tuileries, 1862

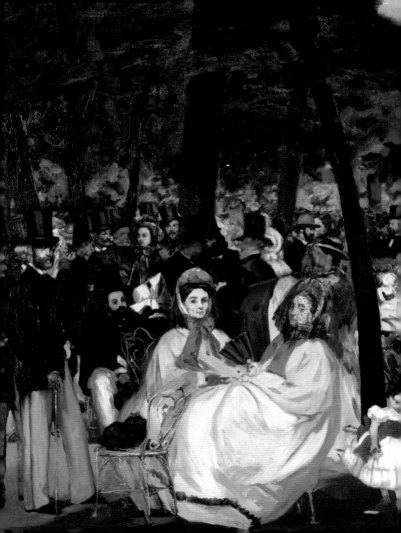

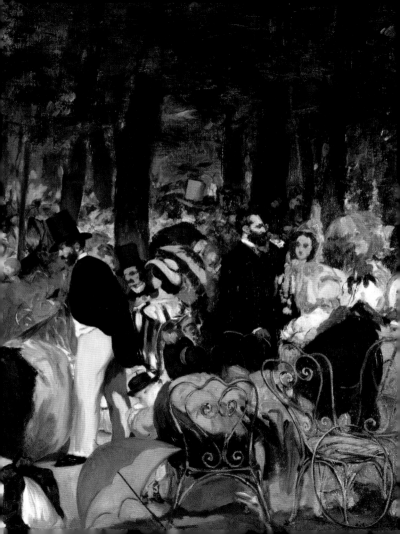

the exhibition hall, he would resort to violence. I can understand why this amateur of the arts was angry. Imagine a crowd, maybe a hundred persons, milling around in the sunshine under the trees of the Tuileries. Each face is just a single blob of paint, barely defined, where details are reduced to lines or black points. Had I been there, I would have asked the amateur of the arts to stand at a respectable distance from the picture; he would have then seen that these blobs are alive, that the crowd is talking and that this is one of the artist's characteristic canvases, one in which he has obeyed to the utmost what his eyes and temperament have dictated.

In the Salon des Refusés, in 1863, Édouard Manet exhibited three paintings. I do not know whether it was because he was a persecuted man, but, on this occasion, the artist did find some people to come to his defence and even some admirers. It must be admitted that his contribution to the exhibition was one of the most outstanding; it consisted of *Le déjeuner sur l'herbe*, a *Portrait de jeune homme en costume de majo*,[1] and a *Portrait de Mademoiselle V . . . en costume d'espada*.[2]

1. 'Young Man in the Costume of a *majo*', 1863, Metropolitan Museum, New York. 2. 'Mademoiselle V... in the Costume of an *espada*', 1862, Metropolitan Museum, New York.

These last two pictures were considered to be quite outrageous, but they were painted with unusual vigour and were extremely strong in tone. I consider that here the painter showed himself more of a colourist than usual. The paint is always fresh – but savagely and startlingly fresh. The separate masses are applied thickly and boldly and stand out from the background with all the vividness of Nature.

Le déjeuner sur l'herbe is Édouard Manet's largest picture, in which he has realized the dream of all painters – to pose life-size figures in a landscape. One knows how skilfully he has overcome this problem. There is some foliage, a few tree trunks, and in the background a river in which a woman in a shift is bathing. In the foreground two young men are seated facing a second woman who has just emerged from the water and who is drying her naked body in the open air. This nude woman has shocked the public which has been unable to see anything but her in the picture. Good heavens! How indecent! What! A woman without a stitch of clothing seated between two fully clad men! Such a thing has never been seen before! But this belief is a gross error; in the Musée du Louvre there are more than fifty pictures in which clothed people mix with the naked. But no one goes to the Louvre to be shocked.

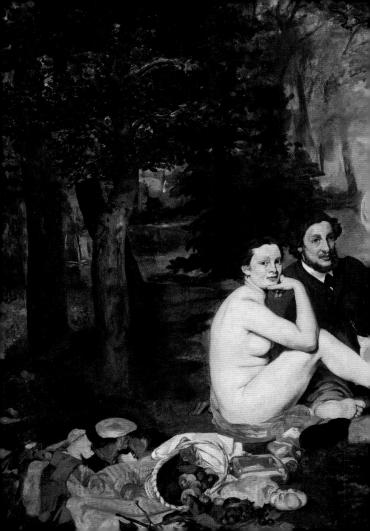

*Le déjeuner
sur l'herbe, 1863*

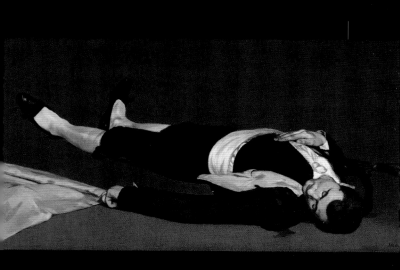

L'homme mort, 1864

Besides, the public has taken good care not to judge *Le déjeuner sur l'herbe* as a true work of art. The only thing it has noticed is that some people are eating, seated on the grass after bathing. It was considered that the artist's choice of subject was obscene and showy, whereas all that the artist had sought to do was to obtain an effect of strong contrasts and bold masses. Artists, especially Manet, who is an analytical painter, do not have this preoccupation with subject matter which, more than anything else, worries the public. For example the nude woman in *Le déjeuner sur l'herbe* is undoubtedly only there to give the artist an opportunity of painting flesh. What you have to look for in the picture is not just a picnic on the grass, but the whole landscape, with its bold and subtle passages, its broadly painted solid foreground, its light and delicate background and that firm flesh modelled in broad areas of light, those supple and strong materials, and, particularly that delicate splash of white among the green leaves in the background; in fact to look at the whole of this vast, airy composition, at this attention to Nature, rendered with such accurate simplicity – at the whole of this admirable work, in which the artist has concentrated his unique and rare gifts.

In 1864, Édouard Manet exhibited *Le Christ mort et*

les anges and an *Épisode d'une course de taureaux.*[1] The only portion of this last picture which he has retained is the espada in the foreground – *L'homme mort* – which is very akin in manner to *L'enfant à l'épée*. The painting is tight and detailed, very subtle and solid. I know already that this will be one of the successes of the artist's exhibition, because the public delights to look at pictures closely and does not like to be shocked by the too violent harshness of a sincere originality. For myself, I declare I much prefer *Le Christ mort et les anges*. Here I find again the complete Manet, with his own individualistic direct vision and his bold handling of paint. It has been said that this Christ is no Christ, and I admit that that may be so. For me it is a corpse painted in a full light, boldly and vigorously; and I even like the angels in the background – those children with big blue wings are so strangely sweet and delicate.

In 1865, Manet was still admitted to the Salon where he exhibited *Jésus insulté par les soldats*[2] and his masterpiece, *Olympia*. I say 'masterpiece' and I don't retract the word. I maintain that this painting is the veritable flesh and blood of the painter. It contains

1. 'Incident from a Bullfight', 1864. Cut in two by Manet and re-painted: 'The Bullfight', Frick Collection, New York, and 'The Dead Toreador', National Gallery of Art, Washington, DC, ill. p. 72
2. 'Jesus mocked by the soldiers', 1865, Art Institute of Chicago

Opposite: Le Christ mort et les anges, 1864

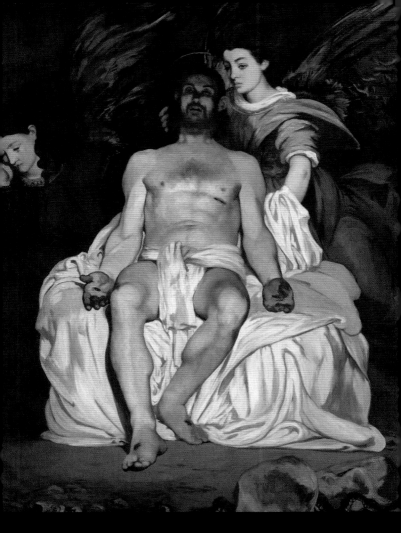

everything the artist has in him and nothing but the artist. It will remain as the most characteristic example of his talent, his greatest achievement. In it I descried the personality of Édouard Manet, and when I made an analysis of the artist's character, it was precisely this picture, which incorporates all his characteristics, that I had in my mind's eye. Here we have one of those 'penny-plain, twopence-coloured' pictures as the professional humorists say. Olympia, lying on white linen sheets, appears as a large pale mass against a black background. In this black background is seen the head of a Negress carrying a bouquet of flowers, and that famous cat which so diverted the public. At first sight one is aware of only two tones in the picture – two violently contrasting tones. Moreover, all details have disappeared. Look at the head of the young girl: the lips are just two thin pink lines, the eyes are reduced to a few black strokes. Now look closely at the bouquet, I beg you. Simple masses of rose colour, blue and green. Everything is simplified, and if you want to reconstruct reality, move back a few paces. Then a strange thing happens – each object falls into correct relation, the head of Olympia stands out in astonishing relief from the background, the bouquet becomes a marvel of brilliance and freshness. Accuracy of vision and simplicity

of handling have achieved this miracle. The artist has worked in the same manner as Nature, in large, lightly coloured masses, in large areas of light, and his work has the slightly crude and austere look of Nature itself. But the artist has his *partis pris*: for art can only exist by enthusiasm. These *partis pris* consist of precisely that elegant dryness and those violent contrasts which I have pointed out. Here is the personal touch, which gives his works their peculiar flavour. Nothing is more exquisitely delicate than the pale tones of the different white of the linen on which Olympia reclines: in the juxtaposition of these whites an immense difficulty has been overcome. The pale colouring of the child's body is charming. She is a young girl of sixteen, no doubt a model whom Édouard Manet calmly painted just as she was. And yet everybody cried out in protest: the nude body was found to be indecent – but naturally, because here was flesh – a naked girl whose charms are already a little faded, whom the artist had thrown on to canvas. When our artists give us a Venus, they 'correct' Nature, but Édouard Manet has asked himself, 'Why lie, why not tell the truth?' He has made us acquainted with Olympia, a contemporary girl, the

Overleaf: Olympia, 1863

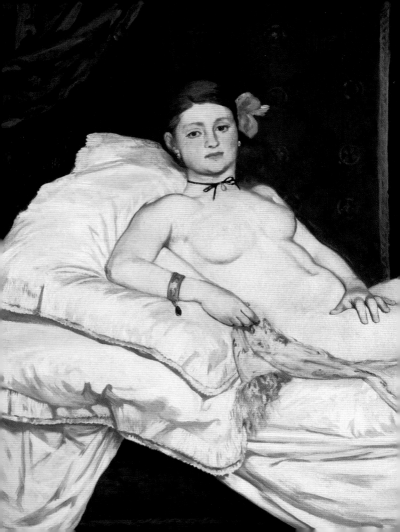

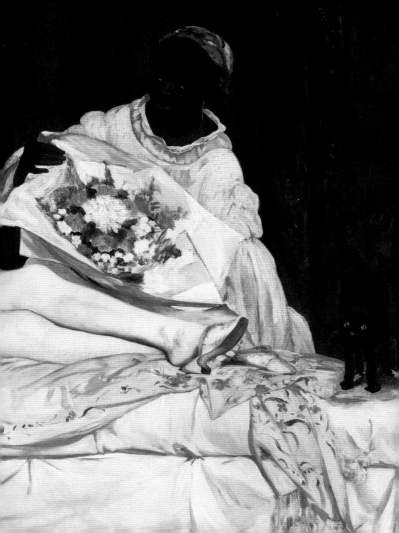

sort of girl we meet every day on the pavements, with thin shoulders wrapped in a flimsy faded woollen shawl. The public as usual has taken good care not to understand the painter's intentions. Some people tried to find a philosophic meaning in the picture, others, more light-hearted, were not displeased to attach an obscene significance to it.

Ho there! proclaim out loud to them, *cher Maître*, that you are not at all what they imagine, and a picture for you is simply an excuse for an exercise in analysis. You needed a nude woman and you chose Olympia, the first-comer. You needed some clear and luminous patches of colour, so you added a bouquet of flowers; you found it necessary to have some dark patches so you placed in a corner a Negress and a cat. What does all this amount to – you scarcely know, no more do I. But I know that you have succeeded admirably in doing a painter's job, the job of a great painter; I mean to say you have forcefully reproduced in your own particular idiom the truths of light and shade and the reality of objects and creatures.

I come now to the last works, those which the public does not know. Note the inconstancy of human beings: Édouard Manet, accepted by the Salon twice consecutively, is flatly rejected in 1866. The strangely

Opposite: L'acteur tragique, 1866

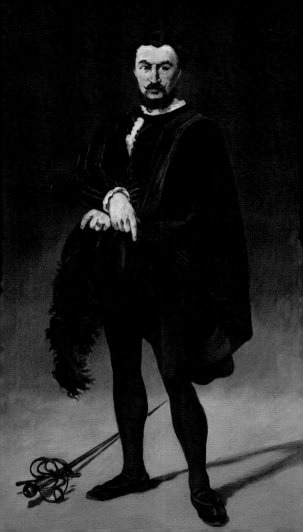

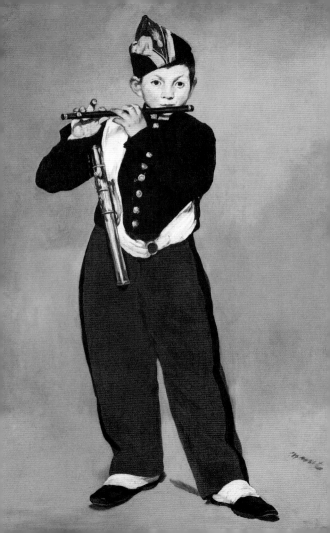

original *Olympia* is accepted, but neither *Le joueur de fifre*[1] nor the *L'acteur tragique*[2] is wanted, pictures which, while representing the complete personality of the artist, are not so highly expressive of his art. *L'acteur tragique* (a portrait of Rouvière in the costume of Hamlet) is wearing a black garment which is a marvel of skill. I have rarely seen such subtleties of tone and such apparent ease in the painting of juxtaposed materials of the same colour. On the other hand I prefer *Le joueur de fifre* – a fine little fellow – a boy bandsman, who is blowing down his instrument with all his might. One of our great modern landscape painters has said that this picture is a 'tailor's shop-sign', and I agree with him if by that he meant that the costume of the young musician is treated with the simplicity of a poster. The yellow of the braid, the blue-black of the tunic, the red of the trousers, are here again no more than flat patches of colour. This simplification, produced by the acute and perceptive eye of the artist, has resulted in a picture full of light and naïveté, charming to the point of delicacy, yet realistic to the point of ruggedness.

1. 'The Fifer', 1866, Musée d'Orsay, Paris, ill. opposite 2. 'The Tragedian', 1865-56, National Gallery of Art, Washington, DC, ill. 81

Opposite: Le joueur de fifre, 1866

Finally there are four canvases, scarcely dry: *Le fumeur*,[1] *La joueuse de guitare*,[2] *Portrait de Madame M...*[3] and *Jeune dame en 1866*.[4] The *Portrait de Madame M...* is one of the best of the artist's productions. I must repeat what I have already said: simplicity and extreme accuracy, clear and delicate observation.

In conclusion: that natural elegance which Édouard Manet, the man of the world, has deep within him, is very clearly expressed in his *Jeune dame en 1866*.[4] A young woman in a long, pink peignoir is standing with her head graciously inclined, smelling a bouquet of violets which she holds in her right hand. On her left a parrot bends over on its perch. The peignoir is exquisite, pleasing to the eye, very full and rich. The pose of the model has an indefinable charm. This picture could be altogether too pretty, if the composition had not been stamped with the artist's characteristic austerity.

I was nearly forgetting four very remarkable

1. 'The Smoker', 1866, Minneapolis Institute of Arts 2. 'The Guitar Player', 1866, Hill-Stead Museum, Farmington 3. Possibly painting of Manet's wife now known as *La lecture* ('The Reading'), Musée d'Orsay, Paris 4. 'Young Lady in 1866' (also known as *La Femme au Perroquet* ('Lady with Parrot'), 1866, Metropolitan Museum of Art, New York

Opposite: Jeune dame en 1866, 1866

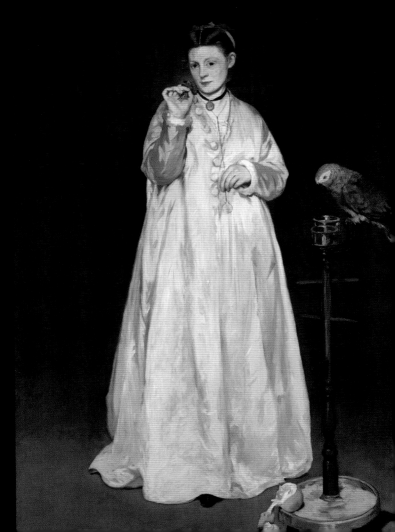

marine subjects: *Le steam-boat*,[1] *Le combat du Kearsage et de l'Alabama*,[2] *Vue de mer: temps calme*,[3] *Bateau de pêche arrivant, vent arrière*,[4] in which the magnificent waves bear witness to the fact that the artist has sailed and loved the ocean. Also seven still-life groups and flower pieces which fortunately are now beginning to be regarded as masterpieces by everybody. The most avowed enemies of Édouard Manet's talent admit that he paints inanimate objects well. That, at least, is a step in the right direction. Amongst the still-life groups, I admired above all a splendid bunch of peonies – *Un vase de fleurs*[5] – and a picture entitled *Un déjeuner*[6] which will always remain in my memory together with *Olympia*.

But after all, the painter is obliged to represent inanimate objects with the greatest cogency, because of the mechanism of his talent, the workings of which I have tried to describe.

1. Probably the painting now known as *Les marsouins* ('The Porpoises'), 1864, Philadelphia Museum of Art 2. 'Battle of the USS "Kearsarge" [sic] and the CSS "Alabama"', 1864, Philadelphia Museum of Art, ill. p. 118 3. 'Seascape: Calm' (also known as 'Steamboat leaving Boulogne') 1864, Art Institute of Chicago 4. 'Fishing boat coming in before the wind' (now known as 'The "Kearsarge" at Boulogne'), 1864, Metropolitan Museum of Art, New York 5. 'A Vase of Flowers', 1864, Musée d'Orsay, Paris 6. 'Luncheon [in the Studio]', 1869, Neue Pinakothek, Munich, ill. pp. 88-89

Such is the work of Édouard Manet, such is the ensemble which, I hope, the public will be invited to see in the galleries of the Universal Exhibition. I cannot believe that the public will remain blind and mocking when they see this harmonious and perfect collection which I have just briefly discussed. There will be such a manifestation of originality and humanity, that truth must be finally victorious. And it is most important that the public should bear in mind that these pictures represent only six years' effort and that the artist is hardly thirty-three years of age. The future lies before him – personally, I dare not confine him to the present.

Overleaf: Un déjeuner, 1866

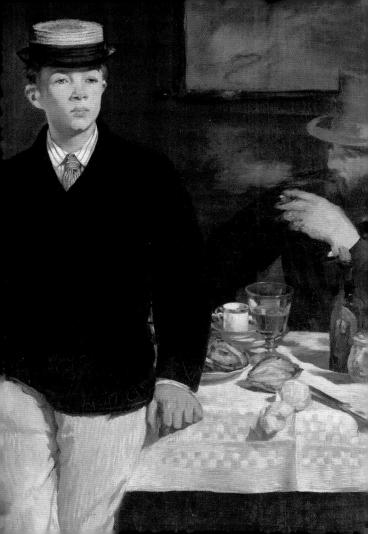

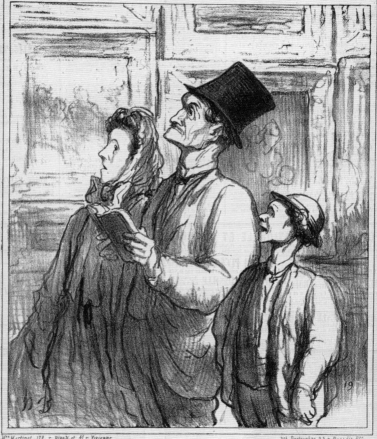

M⁽ᵉ⁾ Martinet, 172, r. Rivoli et 41, r. Vivienne Imp. Destouches, 28 r. Paradis P⁽ˢ⁾

DEVANT LE TABLEAU DE M. MANET 19 Juin 65

— Pourquoi diable cette grosse femme rouge et en chemise s'appelle-t-elle OLYMPIA
— Mais mon ami c'est peut être la chatte noire qui s'appelle comme ça?

III. HIS PUBLIC

It now remains to me to study and explain the attitude of the public towards the pictures of Édouard Manet. The man, the artist and his works are already known. There is another element – the public – which must be taken into account if we are to understand entirely the singular artistic state of things which we seen come to pass. The drama will be complete, we will hold in our hands all the threads connecting the various actors; all the details of this strange adventure.

On the other hand, it would be a mistake to believe that the painter has never met with any sympathy. For the majority, he is a pariah, but for a group of people, which increases in number every day, he is a painter of talent. Latterly, especially, the movement in his favour has increased and become more noticeable. I would astonish the scoffers if I named some of the men who have testified their friendship and

Opposite: Salon sketch by Daumier: published in Le Charivari, *1865.
'In front of M. Manet's painting: "Why the devil is that fat red woman in a nightshirt called Olympia?" "But, my friend, it's perhaps the name of the black cat?"'*

admiration for the artist. Certainly there is a tendency to accept him, and I hope that this will be an accomplished fact in the near future.

Among his painter colleagues there are still some who are blind and who thoughtlessly jeer because they see others jeering. But the genuine artists have never denied that Édouard Manet has great qualities as a painter. Obeying their own individual temperaments, they have made reservations, which is as it should be. If they are guilty of anything, it is for having tolerated that one of their colleagues, a young man of merit and sincerity, should have been made game of in the most undignified way. Because they themselves were able to see clearly; because they as painters understood the intentions of this new artist, theirs was the duty, it seems to me, to silence the masses. I have always hoped that one of them would stand up and tell the truth. But in France, in this fickle and courageous country, there exists a terrible fear of ridicule. Thus at some meeting, if three persons laugh at someone, everybody begins to laugh, and if there should be present any who feel constrained to defend the victim of the scoffers, like cowards they humbly lower their eyes, blushing and ill at ease, and smile half-heartedly. I am sure that Édouard Manet must have made some curious observations on the

embarrassment experienced by some of his acquain-
tances in his presence.

Therein lies the whole story of the unpopularity of
the artist, and I take it on myself willingly to explain
the mockery of some and the cowardice of others.

When the crowd laughs, it is nearly always over a
trifle. Take the theatre, for example: an actor falls
over and the whole auditorium is convulsed with
mirth, and on the following day the spectators will
laugh at the recollection of his tumble. Put ten peo-
ple of average intelligence in front of a new and orig-
inal picture and these people, all ten, will behave in
the most childish way. They will nudge each other
and comment on the picture in the drollest way
imaginable. Curious idlers, in their turn, will arrive
on the scene to swell the group and soon it will turn
into a real hubbub – an access of mad folly. I'm not
making up anything. The artistic history of our times
is there to tell how such purblind fools and scoffers
gathered in front of the first paintings by Decamps,
Delacroix and Courbet. A writer told me some time
ago how once, having had the misfortune to mention
in some salon or other that he found Decamps's work
not displeasing, he was summarily shown the door.
For jesting is catching, and one fine morning Paris
awakes to find it has acquired a new plaything.

Then the situation becomes delirious. The public has a bone to pick. A whole army exists whose interest is to keep the public amused, and which succeeds very satisfactorily: caricaturists seize on to the man and his work; journalists jeer even louder than the disinterested scoffers. In the main, it is mere mockery which is nothing but hot air – there is not the least conviction, not the slightest consideration for truth. Art is something serious and profoundly boring. One has to laugh at it a bit and some picture must be found in the Salon which can be turned to ridicule, and it is always a fresh work, the ripe fruit of some new personality which is picked for the purpose.

Let us look again at this work. We will see that it is simply the more or less original appearance of the picture which has induced this idiotic mirth. The pose is excruciatingly funny! This colour makes you cry with laughter! This line has made more than a hundred people sick! All that the public has seen is a subject – a subject treated in a certain manner. They look at works of art in the same way as children look at picture books – to amuse themselves, to get some fun out of them. Ignorant people laugh with complete self-assurance; knowledgeable people – those who have studied art in moribund schools – are annoyed, on examining the new work, not to discover in it the

qualities in which they believe and to which their eyes have become accustomed. No one thinks of looking at it objectively. The former understands nothing about it, the latter make comparisons. None of them can 'see', and hence they are roused to mirth or anger. I repeat, it is simply the superficial way the work presents itself to the eye that is the cause of all this. The public never tries to probe further. They have stuck, as it were, on the surface. What is shocking and irritating to them is not the inner meaning of the work, but the general superficial aspect of it. If it were possible, the public would willingly accept the same subject matter, presented differently.

Originality! That's what shocks. We are all more or less, without knowing it, creatures of habit who obstinately follow the same beaten path to which we are accustomed. Every new path alarms us, we shy at unknown precipices and refuse to go forward. We always want to have the same horizon before us; we laugh at, or are irritated by the things we don't understand. That is why we are quite happy to accept originality when it is watered down but reject violently anything that upsets our preconceived ideas. As soon as someone with individuality appears on the scene, we become defiant and scared; we are like suspicious horses that rear at a fallen tree across

the road because they can't comprehend either the nature or the cause of this obstacle and don't seek any further to explain it to themselves.

It is only a question of what you are used to. By dint of seeing the obstacle, fear and mistrust are diminished. After that there is always some kind passer-by who will make us ashamed of our anger and explain to us the reason for our fear. I want to play the modest role of the passer-by for the benefit of those who, mistrusting the pictures of Édouard Manet, remain cavorting and frightened on the road.

The artist is beginning to get tired of his role of scarecrow. In spite of all his courage, he is beginning to feel that he is losing his strength in the face of the public's exasperation. It is high time that the public drew nigh and recognized the reason for their ridiculous fear.

But we have only to wait. The public, as I have said, is just a great baby without any convictions and always ends up by accepting the people who have minds of their own. The eternal story of neglected talent which is later fanatically admired, will be repeated in the case of Édouard Manet. His fate will be the same as that of Delacroix and Courbet, for example. He has reached that point where the jibes are now beginning to slacken off, where the public is

beginning to feel uncomfortable and asks nothing better than to become serious again. Tomorrow, if not today, he will be understood and accepted.

If I lay stress on the public's attitude towards every original painter, it is precisely because the study of this aspect of affairs is my general theme for the next few pages.

The public will never cease to be shocked. In a week's time, Édouard Manet will most likely be forgotten by the mockers, who by then will have found another subject for their mirth. A new energetic individualist will only have to reveal himself for you to hear more cat-calls and hissing. The last-comer is always a monster, the mangy sheep of the flock. The artistic history of our latter days is there to prove the facts of the case, and simple logic is enough to show that it will inevitably be repeated so long as the masses refuse to judge a work of art sensibly.

The public will never be fair towards true artists so long as it fails to regard a work of art solely as a free and original interpretation of Nature. Is it not sad to remember, today, that Delacroix was hissed in his time and that his genius was despised and was triumphant only after his death? What do his detractors think now, and why don't they speak out and admit that they were blind and unintelligent? That

should be a lesson to them. Perhaps it would teach them to understand that there is no 'common denominator', nor rules, nor obligations of any sort – only living men, bringing with them a liberal expression of life, giving their flesh and blood, becoming more glorious as they become more personal and perfect. In that case one should make straight away for the pictures which are strange and bold – those would be the ones which should be attentively and seriously studied, in order to see if therein human genius is apparent. One would then disdainfully dismiss the copies and stutterings of spurious painters, and all those pictures worth twopence-ha'penny which are merely the products of a skilful hand. What one needs to look for, above all, in a work of art, is the human touch, a living corner of creation, a new manifestation of humanity in the face of the realities of Nature.

But there is nobody to guide the public, and what do you expect the public to do today in the midst of all this hubbub? Art, in a manner of speaking, is split up. The great kingdom, split into pieces, has formed itself into a host of small republics. Each artist has attracted his public, flattering it, giving it what it

Opposite: Le balcon ('The Balcony'), 1868-69

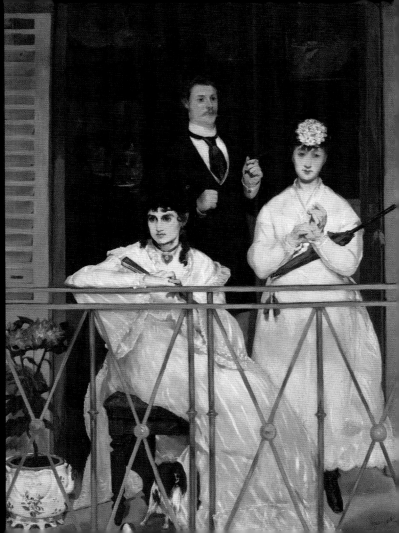

likes, gilded and decorated toys with rosy favours – this art, with us, has become one vast sweet-shop where there are bonbons for all tastes. Painters have merely become pathetic decorators who ornament our terrible modern apartments. The best of them have become antiquaries stealing a bit of this or that from the dead masters, and apart from the landscape painters, these narrow-minded and bourgeois decorators have made the deuce of a noise: each one has his own feeble theory, each tries to please and conquer. The mob, fawned upon, goes from one to the other, enjoying today the whimsies of this painter, and tomorrow the bogus strength of that. And all this disgraceful business, flattery and admiration of trumpery, is carried on in the so-called sacred name of Art. Greece and Italy are staked against chocolate soldiers, beauty is spoken of in the way one speaks of a gentleman acquaintance with whom one is on very friendly terms.

Then come the critics to cast still more trouble into this tumult. Art critics are like musicians who all play their own tunes simultaneously, hearing only their own instruments in the appalling hubbub that they are producing. One wants colour, another drawing, a third intellectual quality. I could name one who polishes his phrases and is only happy when he is able

to describe a picture in the most picturesque terms possible, and another, who à propos of a woman lying supine finds occasion to write a discourse on democracy; and yet another who frames his ridiculous opinions in the form of rhyming music-hall couplets. The mob, completely at a loss, doesn't know to whom to turn. Peter says 'white', Paul says 'black'! If one believes the former, the landscape of this picture should be effaced, if one believes the latter, it is the figures that should be effaced, so that in the end nothing remains but the frame, which would be an excellent thing. There is not the slightest analysis in this approach. Truth is not a whole; there are only digressions, more or less. Each looks at the same picture in a different frame of mind, and each one criticizes it according to circumstances or his mood.

So the mob, seeing how little in accord are those who have pretentions of guiding them, allow themselves to admire or jeer as they please. There is no common point of view. A word pleases them, or displeases them – that's all. And note, what pleases them is always the most commonplace, something they have seen every year. Our artists do not spoil them; they have so accustomed them to insipidity, to pretty lies, that they reject the real truth with all their might. It is simply a question of education. When a

Delacroix appears on the scene, he is hissed. Why doesn't he look like the others!...

Once French wit, that wit which today I would gladly exchange for something a little more serious, becomes involved in these matters, the resulting guffaws are enough to cheer the heart of the saddest.

And that is how, one day, a gang of urchins met Édouard Manet in the street and started the rumpus which brought me to a halt – me, a fastidious and unbiased passer-by. I laid information against them as well as I could, asserting that the urchins were in the wrong, and sought to snatch the artist from their grasp and lead him to a safe place. There were some policemen – I beg your pardon, I mean art critics – present, who assured me that the man was being stoned because he had outrageously desecrated the Temple of Beauty. I answered them that Destiny had undoubtedly already chosen the future setting in the Louvre for *Olympia* and *Le déjeuner sur l'herbe*. No one listened, and I retired as the urchins were now beginning to cast sullen looks at me.

My portrait by Édouard Manet: memories of the sitting

Published in *L'Événement Illustré,*
10 May 1868

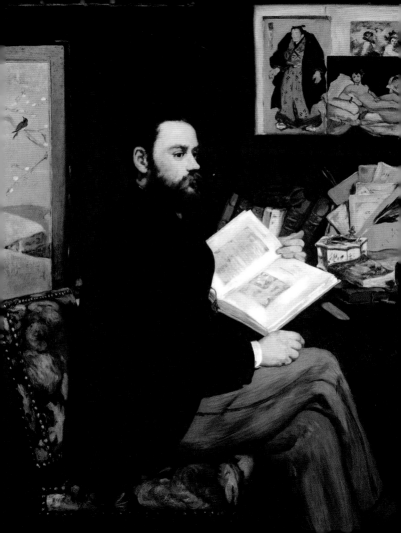

I have just read, in the last edition of *L'Artiste*, these words by Monsieur Arsène Houssaye: 'Monsieur Manet could be an outstanding artist if he had "dexterity"... It is not enough to have a thoughtful brow, or an observant eye: one must have a hand that speaks!'

For me, here is an admission well worth picking on. It is with pleasure that I read this statement by this poet of dainty trifles, this novelist of fine ladies, to the effect that Édouard Manet has a thoughtful brow and an observant eye and could be an outstanding artist. I know that he qualifies his statement, but this reservation is quite understandable. Monsieur Arsène Houssaye, the gallant eighteenth-century epicure, who is misleading us today with his prose and analyses, would like to add a little powder and patches to the artist's sober and precise talent.

I will reply to the poet: 'Don't insist too much that the original and very personal master of whom you speak should be more dexterous than he is. Look at those trompe-l'œil pictures... in the Salon. Our artists are too clever by half; they play like children with puerile difficulties. If I were a great judge, I would have their wrists cut off and open their minds and brains with pincers.'

Opposite: Émile Zola, 1868

However, it is not only Monsieur Arsène Houssaye who dares admit today that there is talent in the work of Édouard Manet.

Last year, at the time of the artist's private exhibition, I read criticisms in several newspapers, praising a large number of his works. The inevitable reaction which I forecast in 1866* is slowly coming about. The public is becoming used to his work; the critics are calming down and have agreed to open their eyes; success is on its way.

But this year it is especially among his colleagues that Manet has met with increasing understanding. I don't think I have the right to quote here the names of the painters who have so heartily and honestly admired the portrait exhibited by the young master. But these painters are numerous and are amongst the best. As far as the public is concerned, it still does not understand, but it no longer laughs. I was amused last Sunday to study the expressions of the people who stopped to look at the pictures of Édouard Manet. Sunday is the day set aside for the real mob, the uninformed, those whose artistic taste has still to be completely developed.

I saw people arriving who had come with the

* On 4 and 7 May in *L'Événement*, reprised in the essay 'A new way to paint', reproduced in this volume

resolve to be slightly amused. They remained with raised eyes, open-mouthed, completely put out, unable to raise the vestige of a smile. Unknown to them, their outlook had become acclimatized. Manet's originality, which had once seemed to them so prodigiously comic, now occasions them no more astonishment than that experienced by a child confronted by an unknown spectacle.

Others enter the gallery, glance along the walls and are attracted by the strange elegance of the artist's work. They come closer. They open the catalogue. When they see the name Manet, they try to force a laugh. But the canvases are there, clear and luminous, and seem to look down on them proudly and disdainfully. They go away, ill at ease, not knowing any more what to think; moved, in spite of themselves by the sincerity of his talent, prepared to admire it in the years to follow.

From my point of view, the success of Édouard Manet is assured. I never dared dream that it would be so rapid and deserving. It is singularly difficult to make the shrewdest people in the world admit a mistake. In France, a man whom ignorance has made a figure of fun is often condemned to live and die a figure of fun. You will see in the minor newspapers, for a long time to come, that there will still be jokes at

the expense of the painter of *Olympia*. But from now on intelligent people have been won over, and as a result the mob will follow.

The artist's two pictures are unfortunately very badly hung in corners, very high, next to the doors. In order to see and judge them satisfactorily they should have been hung 'on the line', under the nose of the public which likes to look at pictures close to. I like to think that it is only because of an unfortunate chance that these remarkable pictures have been relegated where they are. However, although they are badly hung you can see them and from a distance; and placed as they are among trifles and surrounded by sentimental trash, they stand out a mile.

I will not speak of the picture entitled *Une jeune dame.*[1] It is already known to the public and was seen at the artist's private exhibition. I would only advise those clever gentlemen who dress up their dolls in dresses copied from fashion plates, to go and look at the dress which this young woman is wearing; it's true you cannot tell the grain of the material, nor count the stitches; but it hangs admirably on the living body. It is related to that supple cloth, fatly painted, which the old masters cast over the shoulders of

1. Probably *Jeune dame en 1866*, ill. p. 85

their models. Today, artists provide for themselves at a first-rate dressmaker, like little ladies.

As for the other picture...

One of my friends asked me yesterday if I would talk about this picture which is a portrait of myself. 'Why not?' I answered, 'I would like to have ten columns of newsprint to proclaim what I quietly thought during the sittings, while I watched Édouard Manet struggle foot by foot with Nature. Do you imagine that I have so little dignity that I take pleasure in entertaining people with my own physiognomy? Naturally, I will speak of this picture, and any ill-natured people who find it a subject for witticism are merely fools.'

I recall the long hours I sat to him. While my limbs became numbed from not moving, and my eyes were tired from looking straight ahead, the same deep and quiet thoughts continually passed through my mind.

The nonsense that is spread abroad, the lies and platitudes of this and that, all this human hubbub, which flows by uselessly, like so much dirty water, seemed far, far away. It seemed to me that I was outside this world, in an atmosphere of truth and justice and I was filled with a disdainful pity for the poor wretches who were floundering about below.

From time to time, as I posed, half-asleep, I looked at the artist standing at his easel, with features drawn, clear-eyed, engrossed in his work. He had forgotten me, he no longer knew I was there, he simply copied me, as if I were some human beast, with a concentration and artistic integrity that I have seen nowhere else. And then I thought of the slovenly dauber of legend, of this Manet who was a figment of the imagination of the caricaturists, who painted cats as a leg-pull. It must be admitted that wit is often incredibly stupid.

I thought for hours on end of the fate of individual artists which forces them to live apart in the loneliness of their art. Around me, forceful and characteristic canvases, which the public had chosen not to understand, hung on the walls of the studio. It is enough to be different from other people, to think one's own thoughts, to be talented, to be regarded as a monster. You are accused of ignoring your art, of laughing at common sense, simply because your eye and inclinations lead you to individual results. As soon as you no longer follow in the swim of the commonplace, fools stone you, treating you either as mad or arrogant. It was while pondering these ideas that I saw the canvas 'fill up'. What, personally, astonished me, was the extreme conscientiousness of the artist.

Often, when he was coping with a detail of secondary importance, I wanted to stop posing and gave him the bad advice that he should 'invent'.

'No,' he answered me, 'I can do nothing without Nature. I do not know how to invent. As much as I have wanted to paint in accordance with the lessons I have been taught, I have never produced anything worthwhile. If I am worth something today, it is due to exact interpretation and faithful analysis.'

There lies all his talent. Before anything else, he is a naturalist. His eye sees and renders objects with elegant simplicity. I know I won't be able to make the blind like his pictures; but real artists will understand me when I speak of the slightly bitter charm of his works. The colour of it is intense and extremely harmonious. And this, mark you, is the picture by a man who is accused of being able neither to paint nor draw. I defy any other portrait painter to place a figure in an interior so powerfully, and yet avoid making the surrounding still-life objects conflict with the head.

This portrait is a combination of difficulties overcome. From the frames in the background, from the delightful Japanese screen which stands on the left, right up to the very smallest details of the figure, everything holds together in masterly, clear, striking

tones, so realistic that the eye forgets the heaps of objects and sees simply one harmonious whole.

I do not speak of the still-lifes – the accessories and the books scattered on the table. Manet is a past-master where this is concerned. But I particularly draw your attention to the hand resting on the model's knee. It is a marvel of skill. In short, here is skin, but real skin, without ridiculous trompe l'œil. If all parts of the picture had been worked on as much as the hand, the mob itself would have acclaimed it as a masterpiece.

The influence of Manet:
Preface to the catalogue of the
memorial exhibition
1884

On the day after Manet's death, there was an abrupt apotheosis. All the Press bowed down declaring that a great painter had just died. Those who were still joking and quibbling about his work on the previous day, bared their heads and rendered public homage to the triumphant Master who lay finally in his coffin. For us, who had been faithful to him from the beginning, it was a sad victory. What of it! The eternal story repeats itself – the stupidity of the public kills people before putting up statues in their honour! All that we said fifteen years ago – all is now reiterated. Behind the hearse which bears our friend to the cemetery, our heart is softened and weeps at these belated praises which he can no longer hear.

But today, complete amends will have been made. An exhibition of the principal works of the artist has been organized with pious care. The faculty of the École des Beaux-Arts has been kind enough to allow the use of its galleries, an act of intelligent liberalism for which it must be thanked, for there must still be some blockheads among them who will be offended by the entrée of Manet into the sanctuary of tradition.

Behold his work, come and judge for yourselves. We are certain of this last victory which will assign

Opposite: Madame Manet à Bellevue, 1880

him definitely a place among the greatest masters of the second half of the century.

The masters, truth to tell, are judged as much by their influence as by their works – and it is principally on this that I lay stress, because it was quite impalpable. It would be necessary to write a history of our school of painting over the last twenty years to show the all-powerful role that Manet has played therein. He was one of the most energetic instigators of luminous painting (studied direct from Nature and executed in the full light of contemporary surroundings), who little by little has lured our salons away from their bituminous recipes, and cheered them with real sunshine. It is as a regenerator that I wish to portray him in these few, too short pages, whose sole merit is that they are written in all sincerity.

I got to know Manet in 1866. He was then thirty-three, and lived in a large, shabby studio in the Plaine Monceau. He was already in the middle of his struggles. Pictures exhibited at Martinet's, and especially those he sent to the Salon des Refusés, had stirred up all the critics in revolt against him. People laughed uncomprehendingly. Unquestionably, this was the time when the painter was piling up pictures with the greatest confidence, always at work, determined to conquer Paris. His youth had been troubled, there

had been quarrels with his father (a magistrate who was worried by painting), then a desperate journey to America, then lost years in Paris, a period spent in Couture's atelier, a slow and painful period of self-analysis. After that, he faced up to Nature honestly – he never had any other master. And all the while he remained a Parisian, in love with life, elegant and refined, who laughed a lot when the caricaturists represented him as a slovenly dauber.

In the following year, 1867, having been unable to gain admission to the Universal Exhibition, Manet arranged to have all his work assembled in a gallery which he had had built in the Avenue de l'Alma. His œuvre was already considerable, and the artist's approach to out-of-doors painting, which he was to carry to such lengths later on, could be clearly noticed. The first pictures, *Le buveur d'absinthe*, for example, still retained the influence of the 'studio technique', with dark shadows arranged according to formula. Then came the successful canvases, *Le chanteur espagnol* which earned him an honourable mention, and *L'enfant à l'épée*, a picture which was later used as an excuse to destroy his reputation. It was good and sound painting, without much individuality. But the artist, who should have stuck to this manner of painting had he wished to live happily,

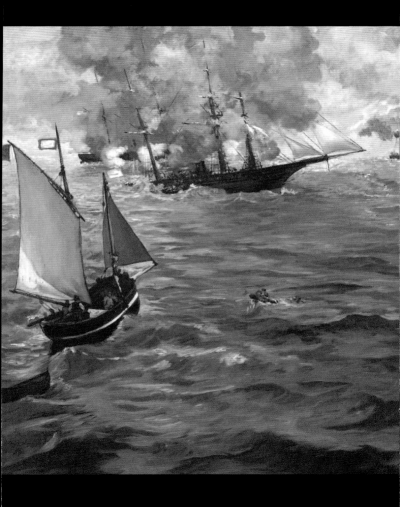

bemedalled and honoured, found to his cost that his temperament led him to make constant evolutions in his art; and, perhaps in spite of himself, he came to paint *La musique aux Tuileries* (exhibited at the Galerie Martinet), the terrible *Déjeuner sur l'herbe* and *L'espada* and *Le majo*, exhibited in the Salon des Refusés in 1863. After that, the rupture was complete. He became engaged in a twenty year battle, which only concluded by death.

How strikingly new and original these pictures in the Avenue de l'Alma were! That exquisite *Olympia* lorded it in the middle of one wall, *Olympia* who, in the Salon of 1865, had succeeded in making Paris exasperated with the artist. There too one saw *Le fifre*, so gay in colour; *Le torero mort*, a fragment of a superb painting; *La chanteuse des rues*, so absolutely right and delicate in tone; *Lola de Valence* – perhaps the gem of the whole exhibition, so charming in its strangeness! I won't mention the marine subjects, among which was the astonishingly realistic *Combat du* Kearsage *et de l'*Alabama. I won't mention the still-life subjects, the salmon, rabbit, and flowers, which even the adversaries of the painter declare to be first-rate, equal to the still-life paintings of the classical Old Masters of the French School.

Opposite: Le combat du Kearsage *et de l'*Alabama ('Battle of the USS "Kearsarge" [sic] and the CSS "Alabama"'), *1864*

This private exhibition naturally made the critics furious with Manet. Insults and jibes abounded. He was as yet not seriously hurt by them, although a natural impatience began to unnerve him. This revolutionary painter, who adored the fashionable world, had always dreamed of the success that would one day be his in Paris, of the compliments of women, of the welcoming praise of salons, of a life of luxury in the midst of an admiring public. He left his dilapidated studio in the rue Guyot and rented a sort of very ornate gallery – an old fencing school, I believe – and took up work again, determined to conquer Paris by charm. But his temperament was always there to deny him the possibility of making concessions, and he was forced in spite of himself, into the path which he had opened. It was at this period that his painting began to become lighter. His desire to please ended with canvases which were more personal and more revolutionary than the old ones. If he worked less, his vision and the way he depicted things, on the other hand, became more highly developed. One may prefer the more muted tones and accuracy of his first manner, but it must be acknowledged that in his second manner, he reached that logical intensity of plein air, that definitive

Opposite: Pivoines (Peonies), 1864-65

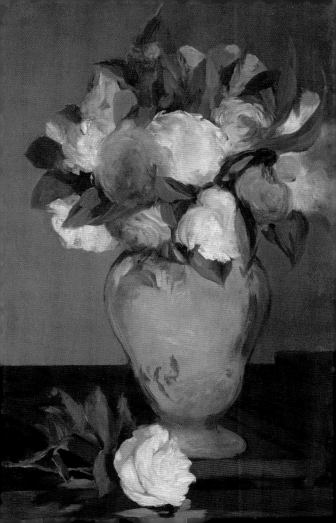

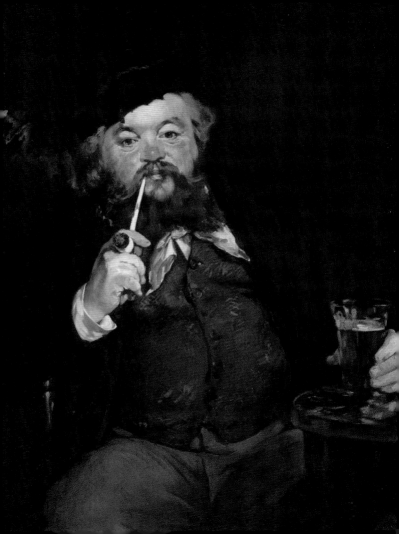

formula which was to have so great an influence on contemporary painting.

To begin with he was enchanted by a success – *Le bon bock*[1] had been praised by everybody. Here was a return to the dexterous handling of *L'enfant à l'épée*, only it was bathed in a fuller light. But he was not always master of his hand, he never employed any fixed method, always retaining the fresh naïveté of a student in the presence of Nature. When he started a picture he never knew how it was going to turn out.

If Genius consists of unconscious reaction and a natural gift for seeing the truth, then he certainly had genius. Nor was he able to rediscover, no doubt in spite of efforts to the contrary, the happy balance of *Le bon bock*, in which his own original touch was tempered by a skill which disarmed public opinion.

One after the other, he painted *Le linge*,[2] *Le bal à l'Opéra*,[3] *Les canotiers*[4] – strongly individualistic canvases which I prefer, but which threw him back once

1. 'The Good Glass of Beer', 1873, Philadelphia Museum of Art, ill. opposite 2. 'Laundry', 1875, Barnes Foundation, Philadelphia 3. *Bal masqué à l'Opéra*, 'Masked Ball at the Opéra', 1873-74, National Gallery of Art, Washington, DC, ill. pp. 34-35 4. 'Boating Couple', also known as 'Argenteuil', 1874, Musée des Beaux Arts, Tournai

Opposite: Le bon bock, 1873

more into the fray, so entirely different are they from the current methods of other painters.

The evolution was complete. He had succeeded in producing light with his brush.

Then onwards, his talent was completely mature. He had once again changed residence. He produced, one after the other, in his studio in the rue d'Amsterdam, *Café-concert*,[1] *Le déjeuner sur l'herbe, Dans la serre*[2] and yet more works, which are easily recognizable by their limpid quality and the transparency of the air which fills the canvas. From this period date also those admirable pastels – portraits of exquisite delicacy and colour.

He was taken ill, but he did not lose courage, and spent the spring in the country from which he brought back sketches of flowers and gardens and people lying on the grass.

When it became impossible for him to walk any longer, he seated himself once more before his easel and painted in this way until the last. Success had come to him, he had been decorated, everyone accorded him the place he merited in the art world of

1. 'At the Café', 1878, Walters Art Gallery, Baltimore, ill. opposite
2. 'In the Winter Garden', 1879, Alte Nationalgalerie, Berlin, ill. pp. 126-27

Opposite: Café-concert, 1878

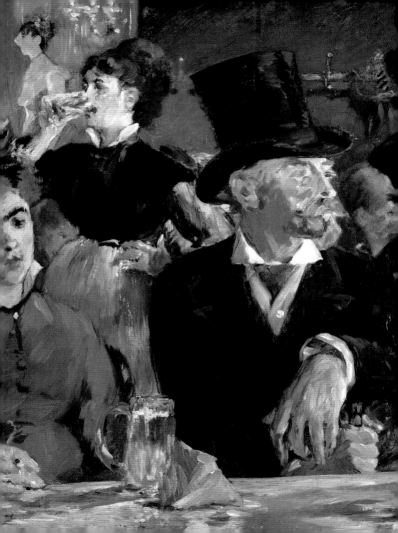

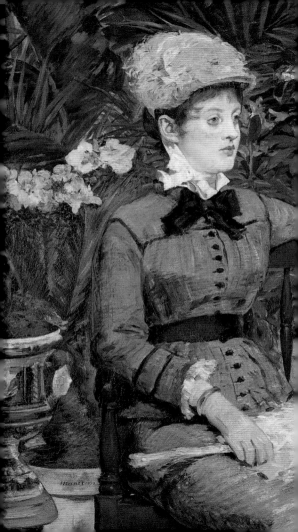

our time. He realized quite well, that if his position was not more publicly acclaimed, only a little effort was yet needed for it to be finally established. He was dreaming of the future, hoping to overcome his illness and finish his task, when death put an end to any resistance to his work and made him stand triumphant.

For us his role was filled. He had put the finishing touch to his work. The years that he might have lived would have only consolidated his conquests. In this rapid review it only remains to me to bring to your notice his portraits which are so contemporary in character – those of his father and mother,[1] of Mademoiselle Eva Gonzalès,[2] of Messieurs Antonin Proust,[3] Rochefort,[4] Théodore Duret,[5] de Jouy[6] and Émile Zola. I would also like to mention his old studies, those very interesting copies: *The Virgin with the Rabbit*,[7] the portrait by Tintoretto,[8] a head by

1. 1860, Musée d'Orsay, Paris 2. 1870, National Gallery, London
3. 1880, Toledo Museum of Art, Toledo, Ohio, illustrated opposite
4. 1881, Kunst-halle, Hamburg 5. 1868, Musée Carnavalet, Paris
6. 1879, Location unknown 7. 1854, Private Collection, New York
8. Copy after self-portrait by Tintoretto, 1854, Musée des Beaux Arts, Dijon

Previous pages: Dans la serre, 1879

Opposite: Antonin Proust, 1880

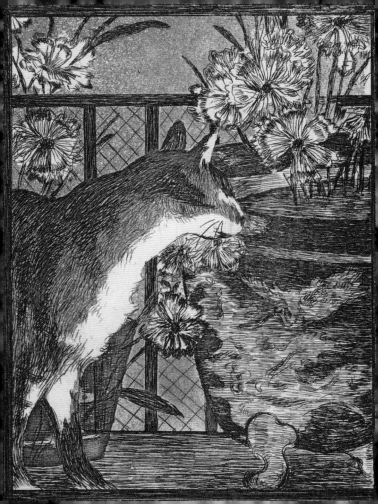

Filippino Lippi,[1] which prove how familiar this painter, who was accused of ignorance, was with the Old Masters. Finally he has left some etchings which are both vigorous and delicate at the same time. Here is twenty-five years of work, battle and victory. This collection shows his whole range of work – how every day he cast away a little of the precepts of art schools, bringing his own vision to bear, by means so clear and obvious that today they have been adopted by all our successful painters.

I don't wish here to assume the job of a critic. I say what is. Manet's formula is quite simple. He just looked at Nature and his whole ideal was to force himself to record it truthfully and forcefully. 'Composition' has disappeared. All that is left are familiar scenes – one or two figures, sometimes crowds, milling around – which he has captured at a glance. One sole rule guided him – the law of 'values', the way someone or some object appears in light. His evolution sprang from that – it is light which forms the design just as much as colour. It is light which puts each thing in its proper place, which is the very life of the subject. Hence those exact tonal

1. Unlocated

Opposite: Le chat et les fleurs ('Cat and flowers'), etching and aquatint, 1869

values of such singular intensity which routed a public accustomed to the traditional false tone values of art school painting. From that moment features became simplified and were treated as large masses in relation to the picture plain, which made the public burst their sides with laughter, accustomed as it was to seeing everything, down to the very hairs of a beard, in the blackened backgrounds of historical paintings. Nothing is more unbelievable, more exasperating than truth, when one's eyes have been blinded by centuries of lies.

It must be added that Manet's personality made this new formula even less acceptable for people who preferred the beaten track. I have mentioned his unconscious approach, his departure into the unknown, each time he placed his white canvas on his easel. Without nature he was powerless. It was necessary that the subject should pose, and then he could attack it as a copyist, without any tricks, without any recipe of any sort, sometimes with great ability, other times extracting from his clumsiness some delightful effects. Hence his elegant ruggedness, with which he is reproached – those unexpected lacunæ which are to be found in his less successful works. His fingers did not always obey his eyes, which were marvellously acute. If he made mistakes, it was not

because of lack of study, as has been claimed, because no painter has ever worked with such tenacity as he. It was simply that he was constitutionally made this way. He did as well as he could and could not paint in any other manner. But he had no *parti pris* – he really would have liked to please.

He gave up his whole life to his task, and none of us who knew him well ever dreamed of wishing him to be more balanced or more perfect, for had this been the case, he would certainly have lost most of his originality – that sharp light, that exact sense of values and that vibrant quality which distinguishes his pictures from all others.

Forget all ideas about 'perfection' and the 'absolute'. Don't believe a thing is beautiful just because it is perfect according to certain physical and metaphysical precepts; a thing is beautiful because it lives, because it is human. Then you will savour the art of Manet to the full – this art which blossomed just at the hour when it had a message to impart and which it delivers with such originality. It is intelligent and witty, much more so than those clever 'what-d'ye-call-its', now already consigned to the dust of

Overleaf: La dame aux éventails ('Lady with Fans, Portrait of Nina de Callias'), 1873-74

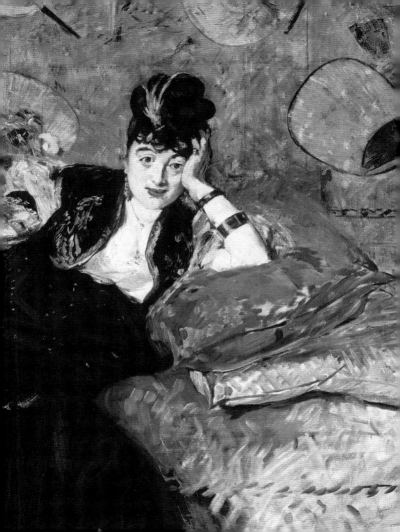

lumber rooms, with which his work was compared in order to discredit him.

His art could only flourish in Paris – it has the pallor of our women by gaslight, it is the true daughter of an obstinate artist who loved society and who wore himself out conquering it.

If you wish to establish exactly the great place which Manet occupies in our Art, try to name some artists who have come after Ingres, Delacroix and Courbet. Ingres remains the champion of our dying Classical School. Delacroix glows throughout the whole Romantic period; then comes Courbet, a realist in his choice of subjects, but Classical in tone and workmanship, who borrowed a skilful technique from the Old Masters. Certainly, after those great names, I do not ignore certain gifted men who have left numerous œuvres, but I am seeking an innovator, someone who has brought a new outlook to bear on life, who, above all, has modified profoundly the artistic outlook of the art schools, and I am obliged to return to Manet, this man who caused such a scandal, who was denigrated for so long and whose influence today is predominant.

The influence is undeniably there, affirming itself more and more at each new Salon. Remind yourself of what was being thought twenty years ago, remember

those dark-hued Salons, where even studies of the
nude remained obscure as though covered with dust.
The big historical and mythological canvases were
smeared with a coat of bitumen. There was no
escape into the real living world, bathed in sunlight,
except where here and there just one small canvas
dared to make a hole in the blue sky.

Then little by little, we have seen the Salons light-
en. Mahogany Romans and Greeks and porcelain
nymphs have been disappearing from year to year,
while the spate of modern subjects, taken from
everyday life, grows higher, encroaching on the walls,
which it lights up with its vivid colours. It was not
only a new world – it was a new sort of painting, a
tendency towards plein air, in which the law of tone
values was respected, in which each figure is painted
in light in its correct relation, and no longer treated
'ideally' in conformity with traditional convention. I
repeat, the evolution is complete. You only have to
compare this year's Salon with that of 1863 for exam-
ple, and you will appreciate the enormous strides
which have taken place in the last twenty years; you
will be aware of radical difference between these two
periods.

In 1863 Manet aroused the public to fury at the
Salon des Refusés, in spite of the fact that he was

leader of that movement. But now how many times one stops in front of bright pictures with clear colour, to exclaim, 'Well, well! a Manet!' He is not a painter one can imitate without admitting it. But it is not the slavish imitators who are by any means the most characteristic – what must be carefully noted is the influence of the artist on the good contemporary painters. While he was being booed for his originality, to which he made absolutely no concessions, all the wily brothers of the brush were gathering crumbs from his table, borrowing from his recipe what the public could not stomach, dressing plein air with bourgeois sauce. I will mention no names, but what fortunes have been made, and what reputations built, on his foundations! He used to laugh a little bitterly sometimes, when he realized he was incapable of these pretty tricks. He was robbed to be served up as a dainty titbit to delighted amateurs, who would have quaked in front of a real Manet, but who swooned before the counterfeit Manets which were manufactured wholesale as goods from Paris.

Things came to such a point that even the École des Beaux-Arts was seduced. The most intelligent of its students caught the infection and broke with the recipes as taught in the school, and threw themselves also into the study of plein air. Today, whether they

admit it or not, all our young painters who are in the vanguard have submitted to Manet's influence, and if they pretend that this resemblance is merely fortu-itous, it is nonetheless evident that he was the first to step out in this direction, thus pointing the way to others. His role as forerunner can no longer be denied by anybody. Since Courbet, he is the last 'force' to reveal himself – by 'force' I mean a fresh development in vision and interpretation.

That is what everybody will understand today, when they look at the one hundred and fifty works which we have been able to collect together here. There is no more argument. We pay homage to the heroic effort of the Master and the great part which he has played in Art. Even those who don't entirely accept him recognize the enormously important place he occupies. Time will succeed in classing him among the great workmen of this century who have given their life that truth might triumph.

Overleaf: La maison à Rueil ('The house at Rueil'), 1882

List of illustrations

All images are by Édouard Manet and are oil on canvas
unless stated otherwise.

Illustrations on pp. 1, 63, 82 and 104 © Bridgeman Art Library; on p. 24 courtesy
of the British Museum; on pp. 2, 8, 18, 28, 31, 40, 64, 66-67, 70-71, 82, 88-89,
99, 114, 122, 125, 126-27, 129, 134-35 and 140-41 courtesy Wikimedia Commons;
on pp. 20 and 78-79 courtesy Google Art Project; on pp. 4 and 45 courtesy J. Paul
Getty Museum; on pp. 4, 12, 56, 61, 75, 85, 121 and 130 courtesy of The
Metropolitan Museum of Art; on pp. 4, 34-35, 48-49, 72, 81 and 90 courtesy of
the National Gallery of Art, Washington, DC; on p. 118 courtesy of the
Philadelphia Museum of Art

© 2013, 2018 Pallas Athene

Published in the United States of America by the J. Paul Getty Museum, Los Angeles
Getty Publications
1200 Getty Center Drive, Suite 500
Los Angeles, California 90049-1682
www.getty.edu/publications

Distributed in the United States and Canada by the University of Chicago Press

Printed in China

ISBN 978-1-60606-566-2
Library of Congress Control Number: 2017948424

Published in the United Kingdom by Pallas Athene (Publishers) Limited
Studio 11A, Archway Studios, 25–27 Bickerton Road, London N19 5JT

Series editor: Alexander Fyjis-Walker
Editorial assistant: Anaïs Métais

Text based on translation by Michael Ross

Front cover: Édouard Manet, *Self-Portrait with a Palette*, ca. 1878–79. Oil on canvas,
85.5 x 71 cm (33⅝ x 28 in.). Private Collection. © Christie's Images / Bridgeman Images